The Portrait Now

The Portrait Now

Robin Gibson

National Portrait Gallery

Published for the exhibition, **The Portrait Now**, held at the National Portrait Gallery
from 19 November 1993 – 6 February 1994.

Published by National Portrait Gallery Publications,
National Portrait Gallery, 2 St Martin's Place, London WC2H OHE.

ISBN 1 85514 098 5

A catalogue record for this book is available from the British Library.

Co-ordinated by Joanna Skipwith
Edited by Gillian Forrester
Designed by Pentagram
Printed in England by BAS Printers, Over Wallop, Hampshire.

Cover: detail of Jean Muir, 1992, by Glenys Barton (no. 6)

Contents

Foreword page 6

Acknowledgements page 7

Introduction page 8

The Great and the Good? page 14

Patronage page 28

Artist as Model page 42

Family and Friends page 54

A Means to an End page 68

In Search of the Self page 80

Catalogue page 93

Index of Lenders page 126

Index of Artists page 127

Foreword

The Gallery's major exhibitions are usually devoted either to the work of a particular artist, in whatever medium, or to the life and times of a distinguished individual. They are scholarly surveys of their subject. But there are other kinds of exhibition, which can be treated in no less scholarly a fashion, that we should also mount. *The Portrait Now* is one of these.

In this exhibition, carefully selected and most sensitively introduced and catalogued by Robin Gibson, we survey a decade of international portraiture - the decade or so since 1980 - and try to examine how a range of painters and sculptors, many of them among the most highly regarded artists of our time, have grappled with the portrait, and, through portraiture, responded to the human condition in an increasingly troubled world. Art since, let us say, the last Impressionist exhibition of 1886, with which the movement disintegrated, has been in a state of continually accelerating experimentation, and most of the images in the present show are, of course, far removed in character from the portraits - however intense or even, occasionally, expressionist - contained in the permanent collection. But, in their different ways, they greatly enlarge our vision of what it is the portraitist can do, just as writers like Samuel Beckett and Harold Pinter have enlarged our expectations of what the dramatist can say. As Herbert Read so wisely wrote many years ago, the genuine artist 'can only be true to himself and to his function if he expresses [his acuteness of sensibility] to the final edge. We are without courage, without freedom, without passion and joy, if we refuse to follow where he leads'.

John Hayes
Director
September, 1993

Acknowledgements

The exhibition could not have taken place without the generous cooperation of all the lenders to the exhibition and the support and encouragement of the Director of the Gallery, John Hayes. To him and my colleague Honor Clerk who wrote the biographies of the artists and four catalogue entries, helped with research and advice throughout preparation for the exhibition, I owe my greatest debt of thanks. The Gallery Exhibitions Officer, Kathleen Soriano, has also been a tower of strength, cutting through seemingly intractable logistical problems with speed and efficiency. Several people were particularly helpful in early discussions about the content of the exhibition; special thanks must go to Marco Livingstone, who made a number of very useful suggestions, Robin Vousden, Richard Morphet and Catherine Lampert.

Many curators and galleries helped with obtaining loans and providing information. Geoffrey Parton and John Erle Drax (Marlborough Gallery, London), John Cheim (Robert Miller Gallery, New York), Anne Blümel (Michael Werner Gallery, Cologne), Douglas Baxter (Pace Gallery, New York), Jeffrey Figley (Sidney Janis Gallery, New York), Andrew Wyld (Agnew's), Andrew Mummery (Raab Gallery, London), Matthew Flowers and Karen Demuth (Flowers East, London), Andrew Murray (The Mayor Gallery, London), Carolyn Carr (National Portrait Gallery, Washington), Robin Vousden and his colleagues (Anthony d'Offay Gallery, London), Professor Klaus Honnef (Rheinische Landesmuseum, Bonn), Klaus Kiefer (Galerie KK, Essen), Herr C. Schwind (Galerie Schwind, Frankfurt), M. Loic Malle (Paris), and Anthony Reynolds, Leslie Waddington, James Kirkman and Mrs Marlee Robinson (all of London). Robert Pincus-Witten of the Gagosian Gallery, New York directed my attention to the David Salle portrait and contributed information about the work for the catalogue.

My greatest regret in organising the exhibition was the necessary omission for reasons of space of a number of British artists, some very well known to me, whose work I admire. They will know who they are and I undertake to remedy these omissions on another occasion. Of the artists included, the following earned my special thanks for their help with suggesting loans and providing information: Avigdor Arikha, Clive Barker, Glenys Barton, Alex Colville, Stephen Conroy, Anthony Green, Allen Jones, Panayiotis Kalorkoti, R. B. Kitaj, Leon Kossoff, Humphrey Ocean, Bryan Organ, Tom Phillips, Sara Rossberg, John Ward, John Wonnacott, Tom Wood and Karen S. Kuhlman of the David Hockney studio. Finally, among the lenders, Tim Miller and Barry Townsley were particularly helpful; and the owners of R.B. Kitaj's *The Neo-Cubist* kindly agreed to its early withdrawal from the opening exhibition at the Astrup Fearnley Museum of Modern Art, Oslo.

Robin Gibson, September 1993

The Portrait Now

A rumour greatly exaggerated

The Portrait Now was conceived as a contemporary update of the *Twentieth Century Portraits* exhibition which I organised at the National Portrait Gallery in 1978. The aim then was to give as positive and as wide a view as possible of the achievements of portraiture in twentieth century art. The intention of *The Portrait Now* is to attempt a similar survey for contemporary art. In 1978, it seemed necessary to try and provide a corrective to the widely held view that portraiture was a dead duck that had been laid to rest at about the same time as Sargent in 1925. The dominance of the twentieth century 'will to abstraction' appeared to have been barely dented by the various mid-century figurative movements which had emerged in reaction to it; R. B. Kitaj's concept of 'The School of London' had not yet caught on and the 'New Spirit' was unheard of. Fifteen years later, the situation has changed considerably; pure abstraction is now enjoyed as one rather exquisite manifestation of the twentieth century aesthetic. Despite an unparalleled diversity of more or less traditional styles in contemporary painting and sculpture, various forms of minimalism and conceptualism from the mud and stones of Richard Long to the ambitious set pieces of Damien Hirst, dominate the exhibition and acquisition programmes of most western galleries and museums. While these might be interpreted as an attempt to carry twentieth century abstraction to its logical conclusion, such often intrinsically ephemeral works seem unlikely to attain even the limited appreciation enjoyed by abstract art produced as long as eighty years ago. Contemporary conceptualism with its self-portrait heads of frozen blood and casts of parts of the artist's body is indeed often less than a step away from portraiture and, for one whose whole working life has been embroiled with the subject, bears out my belief that as long as there is humanity, portraiture in one form or another will continue to be a primary force in the visual arts.

At the other extreme lies an orthodoxy of a totally different sort. Although a stranger to galleries of modern art (except on occasion to the peculiarly historical requirements of national portrait galleries), functional or domestic portraiture continues to flourish throughout the western world. There are roughly a thousand British artists in the contemporary files of the National Portrait Gallery and almost certainly an equivalent number working in a similar or related national style in most of greater Europe and the USA. Ranging in style from the blatantly commercial to skilful revivalism, such portraiture needs the patina of time and history to acquire wider significance outside the context in which it was created. Foreign portraits included in this selection are on the whole the work of artists of current international reputation, a number of whom, it should be noted, have executed portrait commissions at various points in their careers. Their work forms an interesting parallel to those widely respected British painters or sculptors such as John Bellany, Tom Phillips, Maggi Hambling, Stephen Conroy, Elisabeth Frink and Glynn Williams whose range of work includes (though is never dominated by) portraiture, both commissioned and personal.

For a long time photography was considered to have been the virus which would destroy portrait painting. In the hands of an expert it continues to prove itself one of the most immediate art forms of the century, but its function as primary documentation is already being superseded by the video-tape for purposes as diverse as police identification and the domestic souvenir. Portrait photography like other photographic genres has tended to follow current styles and practices in painting, but in matters of scale and physical and aesthetic presence can now be seen to have failed to dislodge the supremacy of portrait painting as an art form. Photography remains unrivalled however for its intimacy of scale and poignant documentation of a moment in time forever lost. Perhaps its true, if not only, victim was the portrait miniature which had already been under attack from the ever-increasing availability and efficiency of reproductive and printing techniques throughout the nineteenth century. It is however only for reasons of space that photography is excluded from this survey. To do justice to its achievements in portraiture, even since 1980, would require as much space again and it must be a separate exhibition for another occasion.

Post-modernism and the current free-for-all in the visual arts has found room for portraiture in many forms and this survey will, I hope, reveal substantial manifestations of an age-old phenomenon in previously unsuspected places. During research for the project, especially in Germany where internationally successful artists practise a wide range of approaches to figuration, inquiries about relevant contemporary painters were met with looks of blank amazement and emphatic denials of the continued existence of any forms of portraiture. In Britain, the most modest of portraits of public figures attracts at least one newspaper report, and the success and esteem generated by the National Portrait

Gallery's annual *BP Portrait Award* exhibition has surprised even the most rigorously modernist of critics. It is fair to say, however, that it is probably now a greater coup both socially and intellectually to be seen extensively on the television screen rather than to have one's portrait exhibited at the Royal Academy or the Royal Society of Portrait Painters. It is not only to photography and to the continuing prevalence in museums and the contemporary art market of non-representational art that the portrait owes its gradual marginalization as a major art form. The sheer volume of personal and visual information conveyed by television and other media has robbed painted or sculpted portraits, at least of prominent figures, of much of their mystery and power. It is only in the hands of very considerable artists that it occasionally achieves its traditional magic.

History (art history) has taught us that really great portraits probably only appear once or twice in our lifetimes. Late Rembrandts, or, to take a more recent example, Picasso's *Gertrude Stein*, were indeed perceived at the time of their painting as falling short of current ideals of verisimilitude, and time is needed to appreciate what is or what is not of lasting value. I have taken 1980 as the earliest date for the inclusion of work in what is intended as a contemporary survey and I make no apology for the presence of portraits by four artists, Francis Bacon, Andy Warhol, Alice Neel and Dame Elisabeth Frink who died within the thirteen years covered by this survey. The influence of the first two continues to be paramount both in the work of younger artists and in our understanding of the concept of the contemporary portrait, and the third, Alice Neel, is a unique painter of talent and insight who deserves to be known beyond the USA. The recent death of Elisabeth Frink is a serious loss to British sculpture.

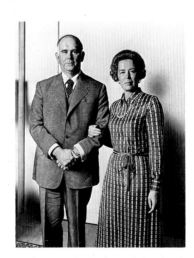

Fig 1: Jean Hucleux
Portrait of Peter and Irene Ludwig 1975-6
Oil on panel, 157 x 123 cms
Museum of Modern Art, Vienna

An international phenomenon

Despite its current relegation to supporting role in the contemporary art scene, the portrait continues to appear in a number of very traditional roles, the portrait of the artist's patron being one of the least suspected. On a par with the patronage of renaissance princes, portraits are being painted of businessmen/collectors such as Hollywood producer Douglas S. Cramer (by Julian Schnabel and Andy Warhol), financiers Gilbert de Botton (by Francis Bacon, no. 4) and Asher Edelman (by David Salle, no. 52) and most notably German chocolate magnate Peter Ludwig by a number of artists whose work he has purchased including Warhol, Bernhard Heisig, the Russian Dmitri Zhilinski (no. 64) and, most spectacularly, by the French photo-realist Jean Hucleux (fig. 1).

Photo-realism which arrived hot on the heels of Pop art and (in American terms at any rate) has, like Pop, been diagnosed as part of the 60s/70s reaction against abstract expressionism, might reasonably have been assumed to provide the way forward for contemporary portraiture. Europe and particularly Britain, however, proved indifferent to its brash and grossly revelatory nature and it has remained (in portraiture) the province of a few experts like Jean Hucleux (no. 32) and Chuck Close (no. 13). In Germany the polymorphic Gerhard Richter has experimented with a diversity of approaches to photography with particular reference to the paradoxical nature of photographic reproduction including blurring and strange viewpoints. His monumental *48 Portraits* (fig. 2) with its necropolistic homage to cultural heroes of the early twentieth century links him directly to the politico-historical work of his slightly younger colleagues in the 'New Painting', particularly Jörg Immendorff and the most impressive of all current history painters, Anselm Kiefer. Kiefer's *Wege* series (fig. 3) comprises powerful collages of numerous portraits of contrasting figures from German history.

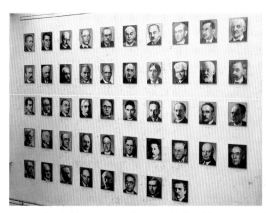

Fig 2: Gerhard Richter **48 Portraits** 1971-2, oil on 48 canvases, each 70 x 55 cms
Ludwig Museum, Cologne (Photo: Rheinisches Bildarchiv) **11**

Immendorff whose *Café Deutschland* and *Café de Flore* paintings (no. 33) contain roll-calls of personal friends and public figures, is one of the outstanding group of major painter/sculptors, including Georg Baselitz, A. R. Penck and Markus Lüpertz, under the wing of gallery owner Michael Werner, all of whom practise various approaches to figuration and have all painted themselves and occasionally each other (fig. 4). Penck and Immendorff were runners-up in the 1987 competition for the 32 meter wall painting for the Pauluskirche in Frankfurt, won by the Berlin painter, Johannes Grützke whose eclectic and often satirical figure paintings and portraits have more in common with the painters of the former East Germany than with the younger *Neue Wilde* group normally associated with Berlin. The neo-expressionism of Rainer Fetting (no. 19), Helmut Middendorf and Salome recalls abstract expressionism in its technique and has frequently been adapted to vigorous self-portraiture. Ironically, the ideological restrictions of life in post-war East Germany and the reaction against the censorship of the Third Reich had already in the 1950s made possible a return to expressionist forms derived more from the painting of Dix, Beckmann and Kokoschka than that of the *Brücke* or *Blaue Reiter* groups. The energetic and imaginative figure paintings of Bernhard Heisig (no. 29) and Willi Sitte in the GDR helped to establish a broadly based figurative school unparalleled since the age of Dürer, Cranach and Altdorfer and they were followed by the scarcely less impressive Sighard Gille (no. 23) and Hubertus Giebe, for both of whom a critical approach to portraiture and to the human comedy remains paramount.

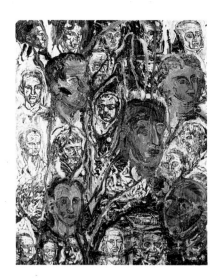

Fig 3: Anselm Kiefer **Wege** (Ways) **II** 1977
Oil on woodcut on paper, 270 x 210 cms
Ludwig Forum for International Art, Aachen

Expressionism as a catalyst for psychological truth in the portrait has been slowly absorbed in both British and American painting. In Britain it ranges from the heightened realism of Lucian Freud (no. 21) through the vigorously analytical approach of Maggi Hambling (no. 27) and the post-Beckmann expressionism of John Bellany (no. 8) to the edge of the psychological abyss in Bacon (no. 4) and the more placid and heavily worked existentialism of Auerbach (no. 3) and Kossoff (no. 39). In the USA it vitalises the eclectic *tours de force* of Schnabel (no. 54) and transfigures the uniquely vivid portraits of Alice Neel (no. 42), despite the distant but evident origins of her work in Matisse also visible in the paintings of Alex Katz (no. 36). There was a point in the 1950s when the styles of Katz and Neel, both of whose work is dominated by portraiture seemed likely to meet. But as the older Neel produced ever more fluent and striking likenesses into her seventies and eighties (including the most revealing of all portraits of Andy Warhol), so Katz developed the quietly deadpan billboard style for which he has become famous and which allies him more closely to Warhol and American Pop. In both Britain and the USA, the now senior artists associated with the Pop movement all continue to produce occasional portraits, whether with the gentle irony of Peter Blake (no. 10), David Hockney (no. 30) or Marisol (no. 41), or with the more sombre existentialism of George Segal (no. 55) or Jim Dine (no. 17). Even one of the founding fathers of British Pop, Eduardo Paolozzi, has been tempted to test the water, underlining the basically humanist approach beneath his long preoccupation with the mechanical debris and confusion produced by mankind (no. 46). Throughout the world of contemporary art, the situation is buoyant; and in between all the passing 'isms', we have in the 1980s and early 1990s seen older artists return to portraiture and younger ones adapt to its demands with a commitment and imaginative vigour which bodes well for the future.

Robin Gibson

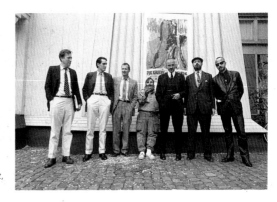

Fig 4: From left to right:
**Michael Werner,
Detlev Gretenkort,
Per Kirkeby, A.R. Penck,
Markus Lüpertz,
Georg Baselitz,
Jörg Immendorff**
Photograph by Benjamin Katz,
Copenhagen, 1985

The
Great
and
the
Good?

In recent times, Andy Warhol has become the best known purveyor of likenesses of the famous and it is now virtually impossible to visualize Marilyn Monroe without his image coming to mind. Equally, much has been written against his apparently indiscriminate use of the portrait; his well known *Chairman Mao* arouses acute hostility probably because, for so political a subject, it could not be obviously propitiatory and yet failed to be openly subversive as Hans Haacke's portraits of Margaret Thatcher and Ronald Reagan were. Apart from his *Joseph Beuys* (no. 58), based on his own Polaroid of 1980, Warhol's more or less objective approach to major contemporary icons is most successful where he has used a second-hand image (like the Monroe and Mao) thus avoiding the interpretative input which we should expect (but are seldom prepared for) from any artist worth his or her salt.

Thanks to television, we all think we know what most famous people look like and inevitably use our own impressions (or at worst those given to us by the media and public relations) to judge an artist's interpretation of a well-known figure. In a free society, any sort of public commission may become a nightmare for the creative artist; though as the example of the Churchill family's disapproval and later destruction of Sutherland's portrait of Sir Winston Churchill demonstrated, the deep-rooted familiarity of relatives and friends can evoke the most destructive criticism of all. For this reason we may find it easier to cope with the totally subjective and more conceptual approach of artists like Marisol (no. 41) or Finer (no. 20), and perhaps avoid considering their work as portraits at all. The admittedly widely differing attempts at objectivity made by Arikha (no. 2), Bellany (no. 8) and Organ (no. 44) have all earned public displeasure in varying degrees.

Marisol: Portrait of Bishop Desmond Tutu (detail)

Avigdor Arikha: Alexander Douglas-Home, Lord Home of the Hirsel (no. 2)

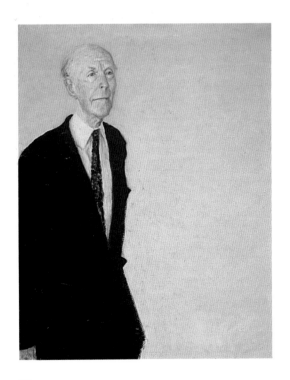

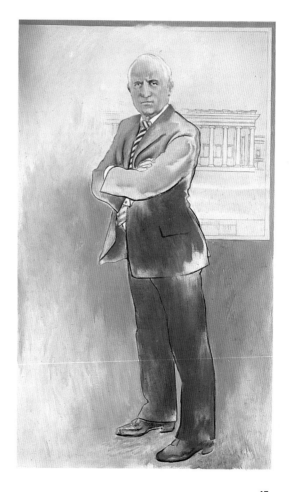

Andy Warhol: Joseph Beuys (no. 58)

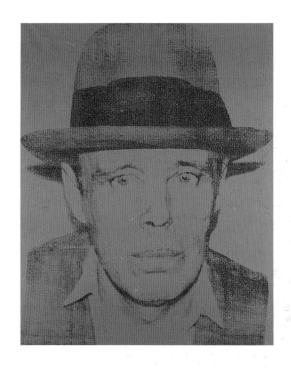

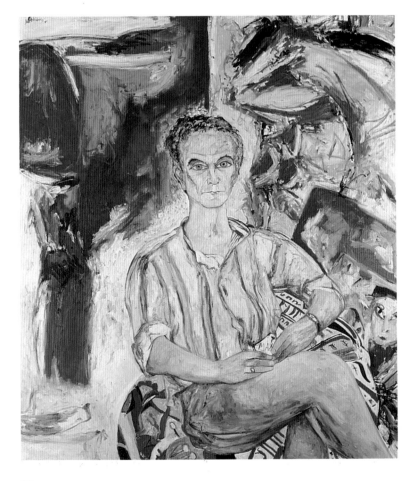

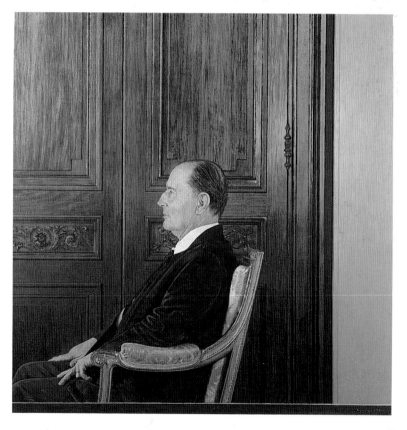

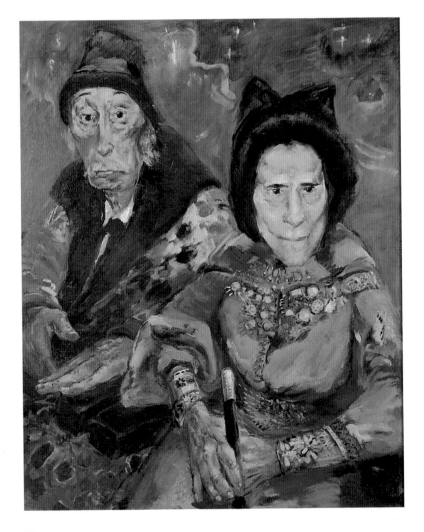

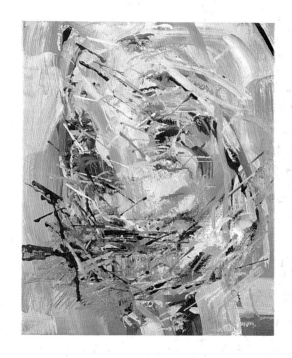

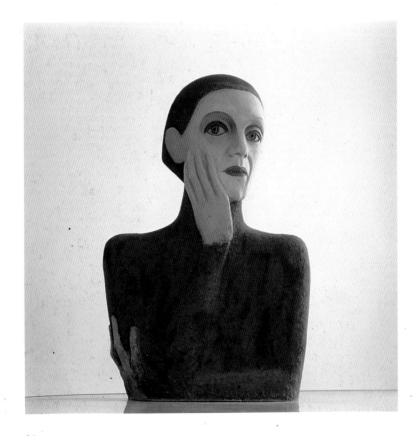

Michael Clark: Vanitas (Lisa Stansfield) (no. 11, verso)

Michael Clark: Vanitas (Lisa Stansfield) (no. 11, recto)

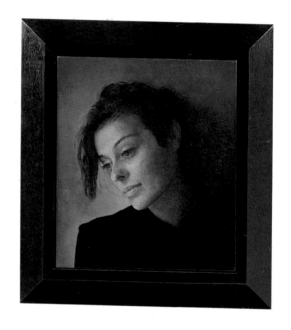

Patronage

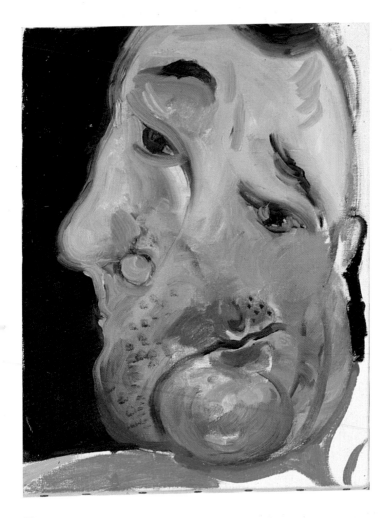

Providing portraits as a service inevitably involves a surrender of freedom of expression which many artists in the post-romantic era have been unwilling to accept. Some exceptionally gifted practitioners have succeeded in raising social portraiture to a high art form (Sargent and Sutherland are outstanding examples), but many of the great figurative painters of modern times have adhered to the prior knowledge and intimacy provided by portraits of close friends and family, and like Bacon (no. 4), Andrews (no. 1) and Freud (no. 21), have only rarely been persuaded to meet the challenge of a portrait of a patron or public figure.

Every Western country has its own allocation of talented craftsmen and women who make a sometimes quite profitable living from commissioned portraiture. Britain in particular has a long, uninterrupted tradition of bourgeois portraiture and John Ward (no. 57) and Bryan Organ (no. 44) are outstanding examples of thorough-going professionals whose integrity has seldom been breached by circumstantial requirements beyond their control. The long-awaited realization that pure photography in no way provides a substitute for the physical and iconic attributes of a portrait created within traditional (and more recent) art forms, has also given confidence to recent generations of artists such as Phillips (no. 48), Hambling (no. 27) and Conroy (no. 15), for whom portraiture is an integral though never dominant strand in their creative output.

David Hockney: Peter Langan (detail)

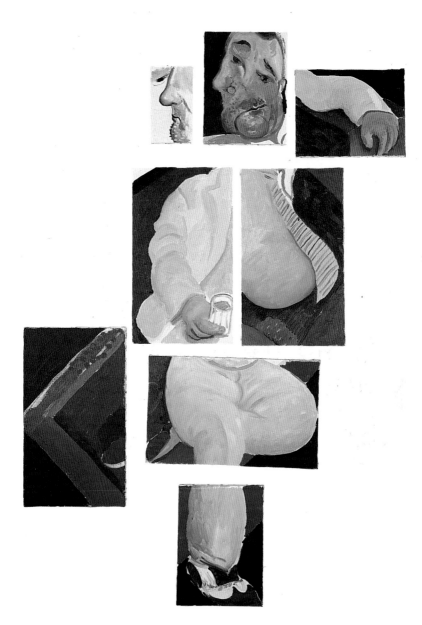

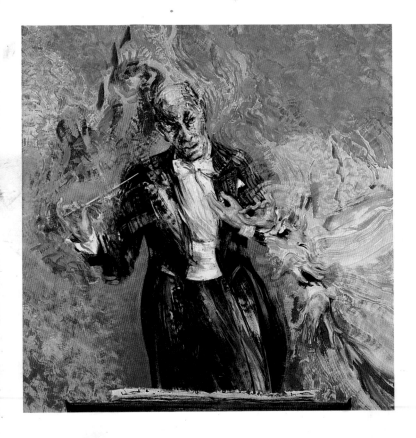

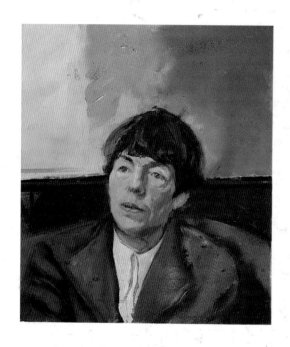

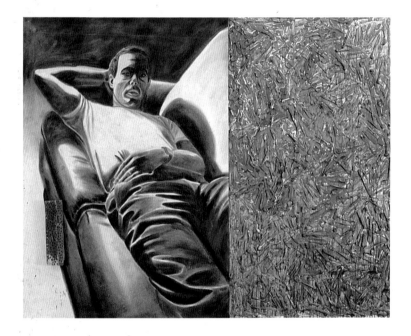

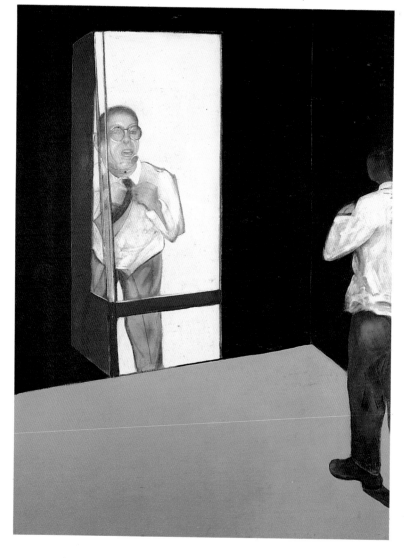

Dmitri Zhilinski: Double Portrait of the Collectors Irene and Peter Ludwig
(no. 64, verso)

Dmitri Zhilinski: Double Portrait of the Collectors Irene and Peter Ludwig
(no. 64, recto)

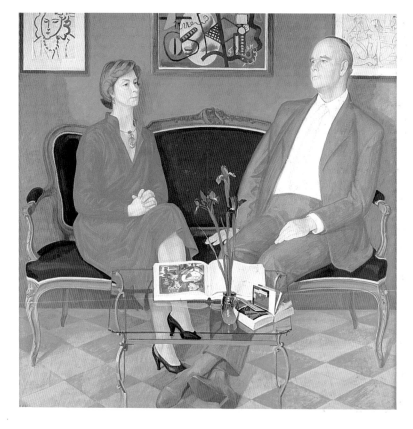

Artist
as
Model

A portrait of another artist - Kossoff's portrait of John Lessore (no. 39) for instance - may indicate nothing more than a tolerant friend who is prepared to sit; but since the almost total extinction of the commissioned portrait as an art form and the expediency of the photograph, which for some artists totally obviates the need for sittings, many good portraits today are the result of the artist's selection rather than the sitter's judgement. Like all professional groups, artists seek friendships among those with similar backgrounds and shared ideals and the preponderance of portraits of arts figures in the National Portrait Gallery's modern collections reflects not bad planning but simple fact. The visual arts in particular depend for their development on the stimulus of other disciplines and approaches, and in many artists' portraits the element of a tribute from one creative personality to another is inescapable. Kitaj (no. 37) in particular has painted a number of memorable compositions around artist and writer friends. It is a perhaps incestuous but nonetheless extremely fertile genre.

Alex Katz: Eric and Peter (detail)

Alex Katz: Eric and Peter (no. 36, recto and verso)

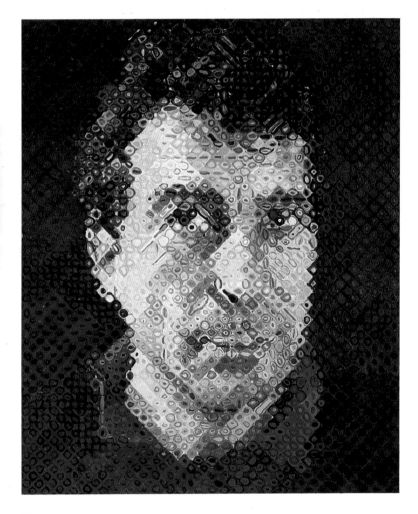

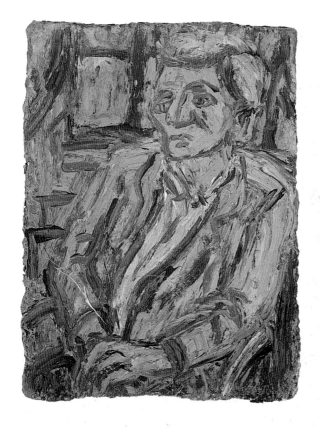

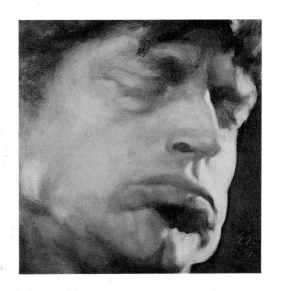

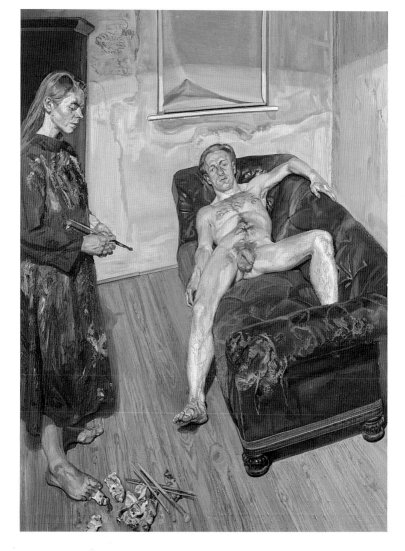

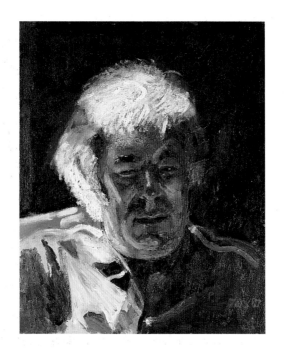

Peter Blake: 'The Meeting' or 'Have a Nice Day, Mr Hockney' (no. 10)

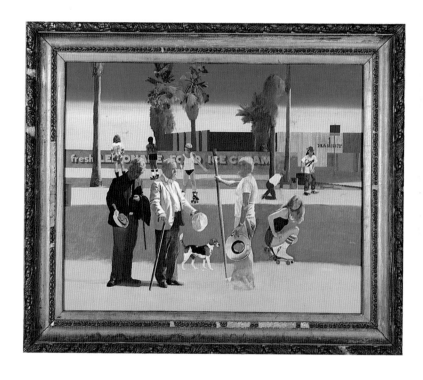

Family
and
Friends

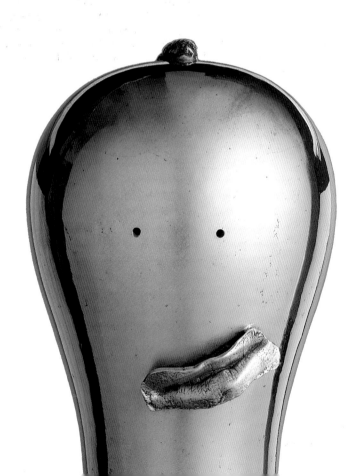

It is a common criticism that contemporary portraits tend to look gloomy and depressed. What people usually mean is that the subject is not seen to be responding to the presence of the artist or indeed to the potential spectator. While this has in part to do with the rigours of long sittings and the technical difficulties of portraying a smile without creating the concomitant look of vacuous inanity, a more pervasive influence is perhaps the existentialist legacy of Giacometti which continues to dominate the long-worked, deeply-felt study of the human face and form, especially among painters of the School of London. 'The adventure, the great adventure is to see something unknown appear each day in the same face', said Giacometti who spent many long hours working on portraits of his wife Annette and his brother Diego. Family and close friends continue to serve as disinterested models for painters like Auerbach (no. 3), Freud (no. 21) and Wonnacott (no. 62), content to be allowed the privacy of their own thoughts rather than obliged to respond and cooperate. Jim Dine's portraits of Nancy (no. 17) represent a similar process of discovery, while for Alex Colville (no. 14), the use of himself, his wife and family as models establishes his personal and total involvement in an apparently objectively observed microcosm. For most of the artists here, family and friends are not only ever-present models, they each have a central role, however passive, within some important aspect of the artist's work.

Clive Barker: Head of Jo House (detail)

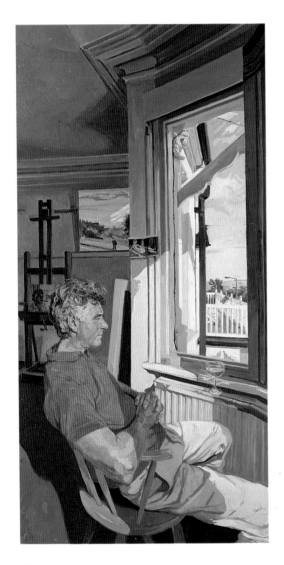

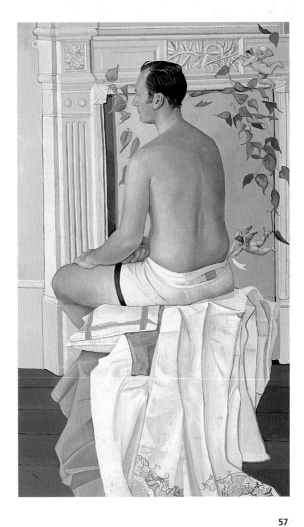

Alex Colville: Couple on Bridge (no. 14)

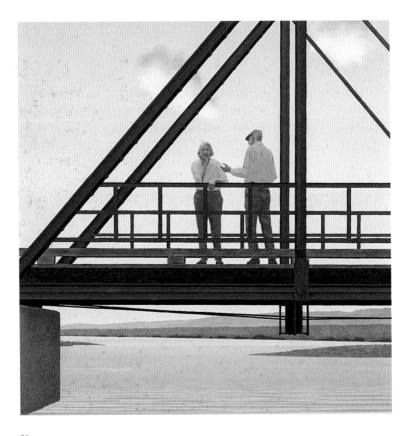

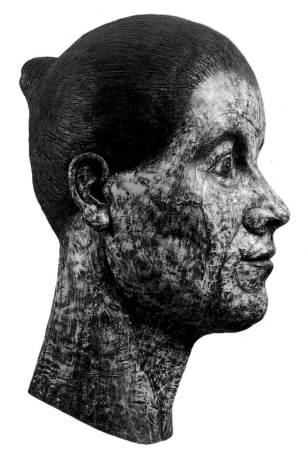

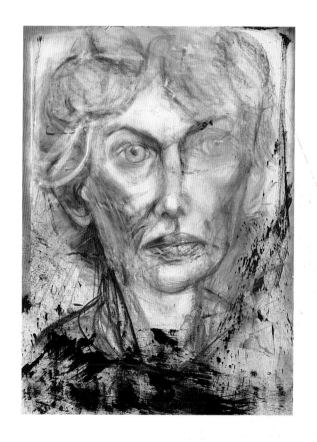

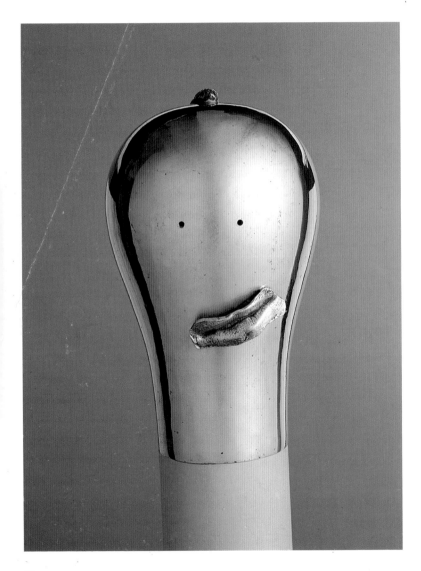

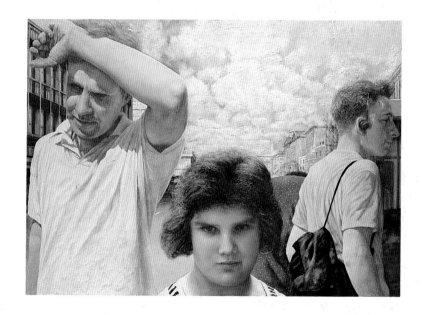

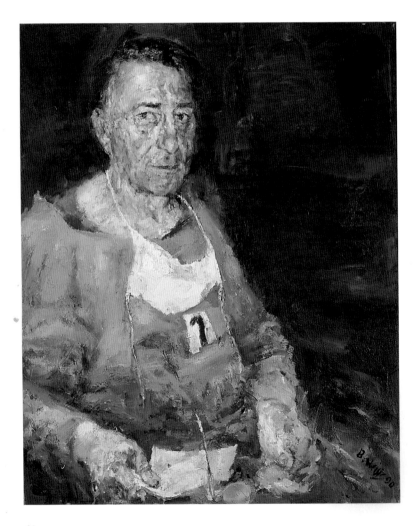

Frank Auerbach: Ruth Bromberg Seated (no. 3)

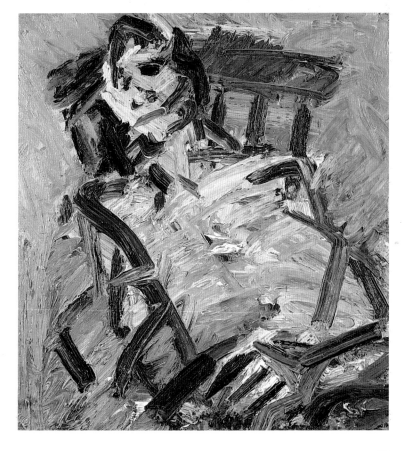

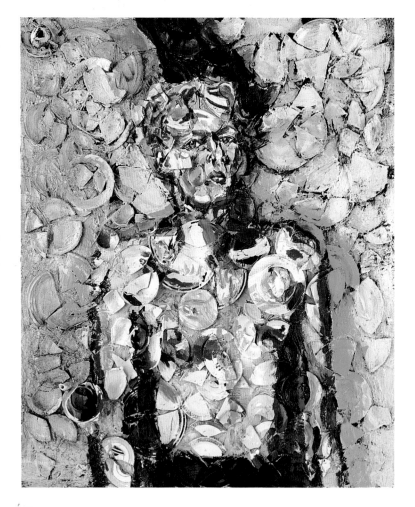

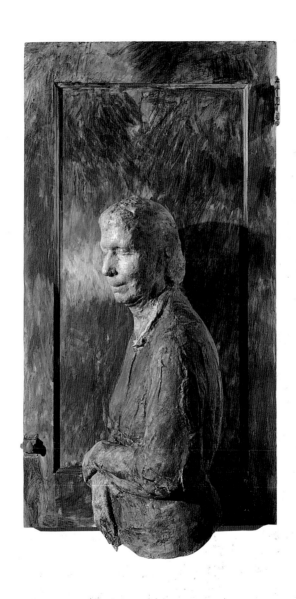

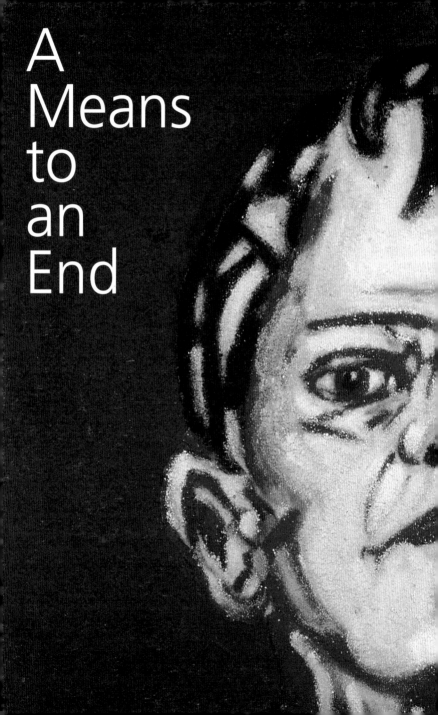

A
Means
to
an
End

In the same way that not every painting of a man, woman or child is a portrait, not every portrait is intended to be recognized as such. Portraiture grew out of early religious and political propaganda imagery, a schematized and usually symbolic figure or face on a coin, icon or tombstone gradually taking on greater particularization until during the Renaissance in Italy and northern Europe portraiture became an end in itself. Applied portraiture is still with us: it can be an instrument of the totalitarian state (Saddam Hussein), a head on a coin (The Queen), a symbol of sentimental humour (Charlie Chaplin) or of glamour (Marilyn Monroe), or it can be a commercial trademark (Colonel Sanders of Kentucky Fried Chicken).

The almost total absence of prevailing stylistic convention has led to a number of contemporary artists using portraiture in an equally wide variety of ways. For some like Hodgkin (no. 31) it may simply be a point of departure for creating a beautiful and personal formulation of colours, marks and textures. For Baselitz (no. 7), the anonymous and transmogrified likeness is intended as little more than the formal element in a basically abstract concept. Immendorff's many portraits (no. 33) are the personal furnishings of his politico-cultural paintings, it making no difference to our appreciation or interpretation (according to him) whether we recognize the personages or not. The anonymous but mostly specific likenesses of Bevan (no. 9), Golub (no. 24) or Kalorkoti (no. 35) may be used as part of a wider statement about human, cultural or political circumstances. Contemporary conceptualists like Cindy Sherman and Toren (no. 56) use the self-portrait as a medium for statements, usually about inexhaustible issues such as life, art, sex and death, though seldom intentionally about themselves.

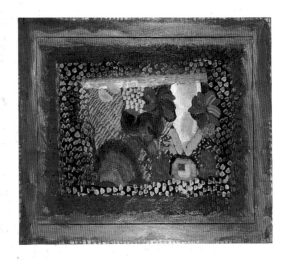

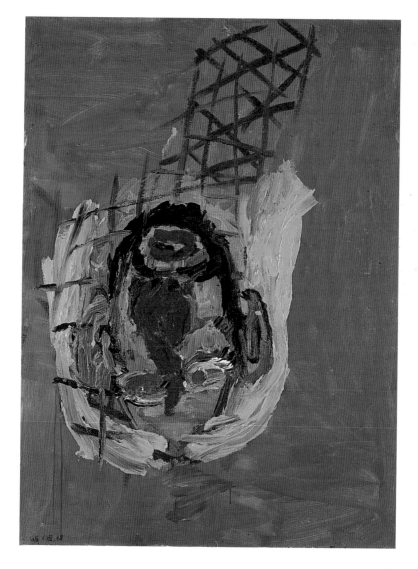

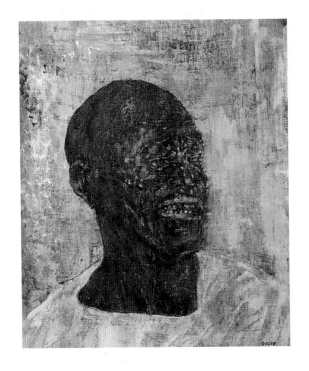

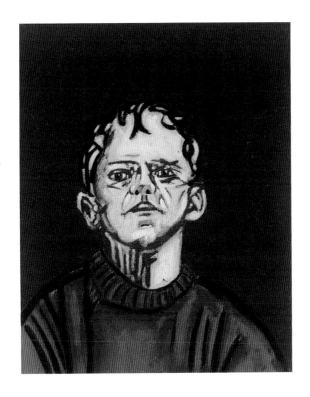

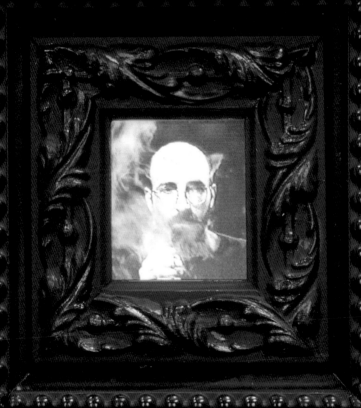

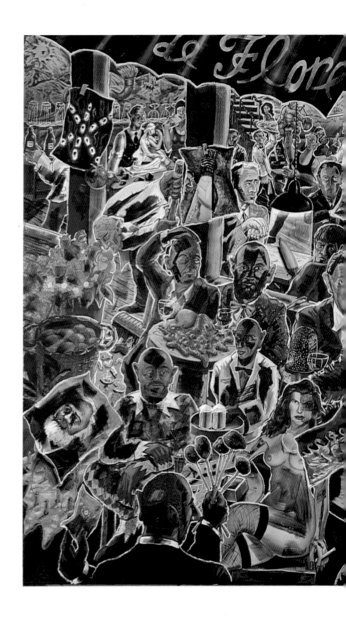

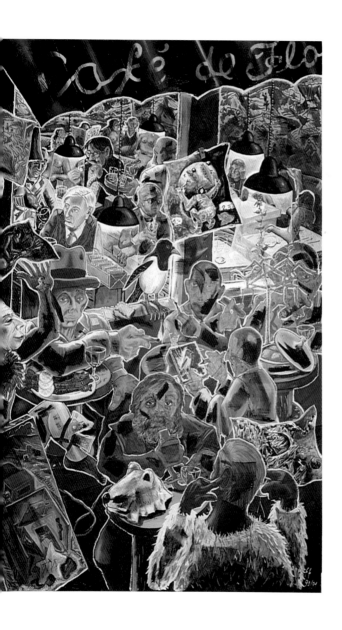

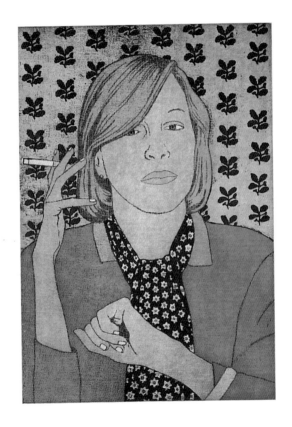

In
Search
of
the
Self

A great many painters attempt at least one major self-portrait during their careers, however abstract their work. Some notable exceptions come to mind - Sargent for instance, indicating an inclination to preserve the privacy implicit in his shyness. Sculpture also seems to have been a bar to self-exploration though Frink (no. 22) and Williams (no. 60) here demonstrate just how rewarding the results can be. Though seldom in the vein of the self-advertising demonstrations of virtuosity by painters of the Baroque era (Koons [no. 38] might be considered an exception), self-portraiture in one form or another is an integral part of contemporary creativity. At their most obvious, self-portraits occur time after time in the work of Bellany (no. 8), Clemente (no. 12) and Immendorff (no. 33), a mark of the central role autobiographical elements play in their subject matter but also of the basically romantic/conceptual nature of their work. This underlying conceptualism unites many of today's leading figurative artists with those of the orthodox avant-garde such as Toren (no. 56) and the *Young British Artists* in the 1993 Saatchi Collection exhibition (like Wallinger and Marc Quinn) who make use of the self-portrait in a more or less didactic way. In a similar manner, painters as diverse as Penck (no. 47), Hambling (no. 27) and Lüpertz (no. 40) have created quasi-abstract self-portraits within the framework of their own current formal investigations.

Glynn Williams: Self-portrait (detail)

Rainer Fetting: Selbstportrait als Rembrandt am Leninplatz (Self-portrait as Rembrandt on Lenin Square) (no. 19)

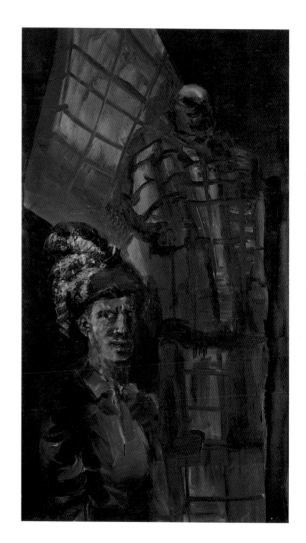

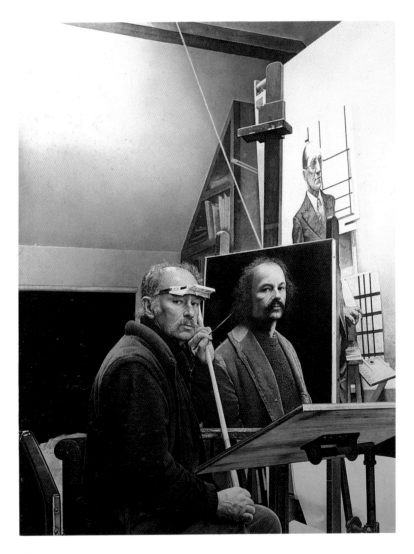

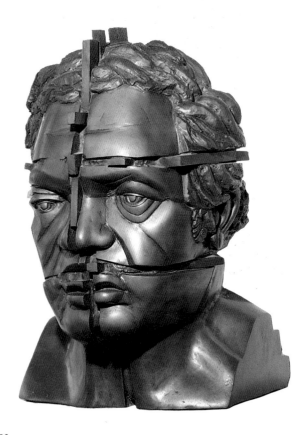

Elisabeth Frink: Self-portrait (no. 22)

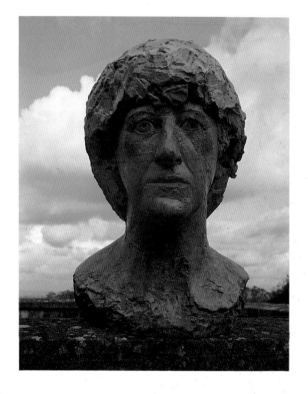

Markus Lüpertz: Selbstportrait (no. 40)

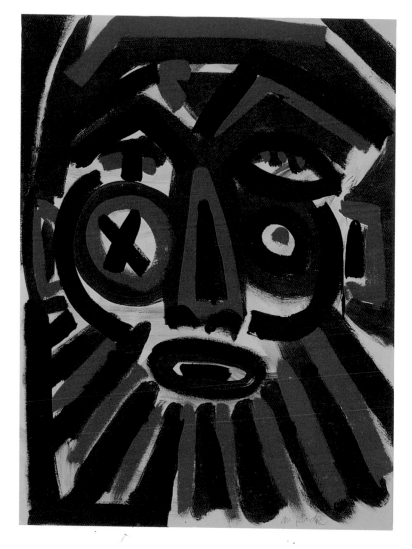

Catalogue

Catalogue entries are arranged alphabetically by artist. For reasons of space, no attempt has been made to provide a provenance or full bibliography for each portrait; instead, the one or at most two works, cited under *Ref.*, may be assumed to give the fullest and most recent information on each artist and, where page numbers are given, the most recent reference to the portrait in question.

Measurements are given in centimetres and inches (in brackets), height before width. The initials *HC* denote catalogue entry by Honor Clerk.

Copyright © in the works belongs to the artists unless otherwise stated.

1

Michael Andrews born 1928
Born in Norwich; painter of landscapes, cityscapes and complex figure groups; identified with the School of London and frequenter, during the early 1960s, of the Colony Room Club whose artistic patrons he depicted in two canvases; his metaphorical use of the physical world is characterized by the series *Lights* (1968-1974) and *Ayer's Rock* (1984-1990). Retrospectives: Hayward Gallery, London, 1980; Whitechapel Art Gallery, London, 1991.

Portrait of Serena, 1989-91 [illustrated p. 35]
Oil on canvas, 40.7 x 35.6 (16 x 14)
Private Collection

Early figure paintings such as *The Family in the Garden*, 1960-2, were painted from life and show the meticulous approach which Andrews had inherited from Sir William Coldstream at the Slade, but nearly all of the large groups of figures from modern life, for which Andrews is best known, make sophisticated use of photographic imagery. A recent group of small portraits including a self-portrait (1988) and this commissioned portrait of the wife of a major patron, show, however, a return to direct painting. The accuracy and intimacy of these small portraits is a reminder of the consummate skill and sensitivity which underlines even the most ambitious of Andrews's large-scale works.

Ref: *Michael Andrews*, exh. cat., Whitechapel Art Gallery, London, 1991.

2

Avigdor Arikha born 1929
Deported from his native Romania and incarcerated in labour camps during the Second World War; reached Israel, 1944; settled in Paris, 1949; designed stained-glass windows and a monumental mosaic for municipal buildings in Jerusalem (1958-68) before returning to figuration and working from life; publications include works on Poussin and Ingres.

Alexander Douglas-Home, Lord Home of the Hirsel, 1988 [illustrated p. 16]
Oil on canvas, 91.5 x 71 (36 x 28)
Scottish National Portrait Gallery

The portraits of those Arikha knows well, his nudes and still lifes, have an intimacy which seems to provide the nearest equivalent to the work of Lucian Freud (cat. no. 21) outside Britain, and he has painted some of the most telling back views in art. Unlike those painters of the School of London who perhaps take their cue from Coldstream and demand a great deal of their sitters (Freud, Auerbach, Uglow), Arikha is diffident about asking for long sittings, especially from the elderly, and draws with his paint onto the canvas to secure as much information as directly as possible (the Scottish National Portrait Gallery's portrait of The Queen Mother was painted in an hour and forty-five minutes). Arikha's portrait of the former Prime Minister might seem unusual to those whose concept of a commissioned portrait of a public figure is closer to something in the nature of a memorial tribute. Clearly the result of direct observation, it suggests complexities of character and tremendous dignity in old age; the remarkable one-sided composition is an eloquent reminder of the sitter's native diffidence.

Ref: R. Channin *et al.*, *Arikha*, Paris, 1985.

3

Frank Auerbach born 1931

Evacuated to Britain from Berlin as a child in 1939; studied painting in London under Bomberg at the Borough Polytechnic, 1947-8, and continued to attend his classes while at St Martin's, 1948-52, and the Royal College, 1952-5; included in David Sylvester's *Critic's Choice* at Tooth's, London, 1958 and in Kitaj's *The Human Clay*, Hayward Gallery, London, 1976. Retrospective: Hayward Gallery, 1978.

Ruth Bromberg Seated, 1992 [illustrated p. 65]
Oil on canvas, 66 x 61.6 (26 x 24 ¼)
Private Collection

If much of Auerbach's *oeuvre* can be seen as a long and passionate affair with paint, it is the depiction of the particular corner of north London where he lives and the close friends who share his life, through which this passion is expressed. Countless portraits of 'E.O.W.', 'J.Y.M.', his wife Julia, and more recently Catherine Lampert, testify to the years of intimate sittings, the pose often as here one of repose rather than the blandly polite responsiveness of many conventional portraits. A new subject (Ruth Bromberg is the first for a number of years) does not give rise to a radically new approach, but is assimilated into the slowly evolving trends of Auerbach's current preoccupations. The semi-reclining pose and sharply defined chair back here echo (in reverse) his portrait of Catherine Lampert of 1987 (private collection, New York). The bold lines, increased legibility and radiant pastel colours contrast strongly with the dense impasto of the sixties and the sombre colours of the late seventies and early eighties. Whether such subtle changes are due in part to the sitter, one can only guess.

Ref: R. Hughes, *Frank Auerbach*, London, 1990.

4

Francis Bacon 1909-92

Dublin-born painter, came to London in 1925; triptych *Three Studies for Figures at the Base of Crucifixion* (Tate Gallery), exhibited in 1945, initiated a career of maverick individuality. Retrospectives: Tate Gallery, 1962 and 1985 (tour to Stuttgart and Berlin); Paris and Düsseldorf, 1971; Hirshhorn Museum, Washington DC (tour to Los Angeles and New York), 1989-90.

Study for a Portrait of Gilbert de Botton Speaking, 1986 [illustrated p. 37]
Oil on canvas, 198 x 147.5 (78 x 58)
Private Collection

The battered photographs of Bacon's friends used for much of his best work in the 1960s were supplemented by an intense social life with the subjects themselves, but Bacon did occasionally accept what amount to commissions with, as here, totally unpredictable results. Neither the enigmatic early portraits of Sir Robert and Lady Sainsbury, nor the 1977 *Three Studies for a Portrait*, however, are as pictorially ambitious as this late work which is visually inventive and enigmatic in mood to the extent that it raises the question whether in his later years Bacon did not need some sort of challenge to bring out his best. Closest in concept and sense of engagement to some of the self-portraits of the seventies and early eighties, the familiar device of the mirror has seldom been deployed to greater effect. Bacon used a photograph taken of the sitter during a speech at the Conference of the Weizmann Institute in Madrid, October 1985; the slightly crumpled and faceless *alter ego* on the right, cut off by the picture frame, is not so much mirrored by the podium-like structure as forcefully projected at the viewer, as if on a video screen. The powerful physical presence of the successful financier in the portrait suggests a man preparing to project himself in a similar way onto his own world.

Ref: Lawrence Gowing & Sam Hunter, *Francis Bacon*, London, 1989, no. 55, ill.

5
Clive Barker born 1940
Born in Luton; included in *Young Contemporaries*, RBA Galleries, London, 1962; chromium-plated sculptures, such as *Splash*, 1967, and *Van Gogh's Chair*, 1966, became icons of British Pop in the 1960s. Retrospective: Mappin Art Gallery, Sheffield (and tour), 1981-2. Later work includes *Boxes* (Wolverhampton Art Gallery 1985) and *Portraits* (National Portrait Gallery, London, 1987).

Head of Jo House, 1981 [illustrated p. 62]
Bronze, 28 (11) high
The Artist

Clive Barker's genius has always been to seize the familiar and translate it into something else. This talent for opening our eyes to the possibilities inherent in even the most commonplace object has led to a recent revaluation of Barker's importance within the British Pop movement, but it is, of course, also a crucial element in the art of portraiture. Barker has produced a number of relatively straightforward portraits, notably the series of friends and contemporaries in oil pastel exhibited at the National Portrait Gallery in 1987. His sculpted portraits, however, are more central to the mainstream of his work. They may take the form of a visual metaphor, like the *Head of Francis Bacon*, 1978 (an elegant brass head of a horror film 'zombie'), or like the *Head of Jo House*, they may focus on the essential physical and personal elements in a subject and reduce them to simple, telling and often witty sculptural form. The wife of painter and designer Gordon House is here transformed into a compact, Brancusi-like shape, but complete with 'real' lips - a personal tribute to the sculptor's sitter, but also a succinct metaphor for the old paradox between art and reality.

Ref: *Clive Barker*, exh. cat., Mappin Art Gallery, Sheffield, 1981, no. 51. Marco Livingstone, *Pop Art*, exh. cat., Royal Academy of Arts, London, 1991.

6
Glenys Barton born 1944
British ceramic sculptor, born in Stoke-on-Trent; studied 1968-71 at the Royal College of Art; exhibited sculptures at Crafts Council Gallery, London, 1977, following 18 month placement at the Josiah Wedgwood Factory, Barlaston, Stoke-on-Trent; work included in public collections throughout Britain and in Australia, Holland, Sweden and USA.

Jean Muir, 1992 [illustrated p. 24]
Ceramic, 52.5 (20 ¾) high
Mr René Schneider

Glenys Barton is essentially a figure sculptor working in her chosen medium of ceramic, and much of her work to date has been concerned with the human head. Classic and static, the mostly anonymous heads, ranging in shades from bronze green to terracotta, nevertheless often have a rather unquiet and disturbing quality: even those heads whose eyes are closed in sleep appear to sigh. Early works included a number of fairly aggressive self-portraits, while 1985 saw the commissioned portrait of Peter Moores, inscrutable with moustache, and 1986 a series of heads of fellow sculptor Richard Deacon in which full advantage was taken of his sculptural features. There was little in these, however, of the unexpected eloquence of the series of sculptures of Jean Muir, the doyenne of the British fashion world. Not only the appearance but the creative personality of Jean Muir pervades the pieces to the extent that it dictates the form, colour and mood of the finished works. A severely beautiful polychrome head echoes the forceful personality of the bust illustrated here while two graceful, tanagra-like figures remain uncoloured and pay tribute in kind to the timeless simplicity for which the designer is known.

Ref: *Glenys Barton: Sculpture*, exh. cat., Flowers East, London, 1993.

7

Georg Baselitz born 1938

Born Georg Kern in Deutschbaselitz, GDR; expelled from the East Berlin Academy, 1956; studied at the Academy of Fine Art, West Berlin 1957-64; *Die grosse Nacht im Eimer* confiscated by the Public Prosecutor's Office, 1963; from 1969 inverted the subjects of his paintings; Professor of the Academy of Fine Art, West Berlin, 1983-92.

Das Motiv: Giraffe, 1988 [illustrated p. 71]
Oil on canvas, 130 x 97 (51 ¼ x 38 ¼)
Hartmut and Silvia Ackermeier, Berlin

'In *Das Malerbild* for example I paint German artists whom I admire. I paint their pictures, their work as painters, and their portraits too. But oddly enough, each of these portraits ends up as a woman with blonde hair. I myself have never been able to work out why this happens'.* A series of pictures on 'motifs' in 1988 (the year after *Das Malerbild*) underlines the paradoxes in Baselitz's art. If there is a motif, it is inevitable that it will be 'read' by the viewer, even if upside down. And if it is called 'Giraffe' and shows a head with long blonde hair, it will not disguise the fact that it is a memorable self-portrait. It is primarily one in a series of powerful Baselitz paintings, biographical (as he describes it) or perhaps, more accurately, autobiographical, both in motif and execution. Deliberate ugliness and deliberate iconoclasm combine - again the paradox - to create a haunting icon of considerable impact and (it must surely by now be admitted) wit.

Ref: Franz Dahlem & Georg Baselitz, *Baselitz*, Cologne, 1990, no. 134 (*quoted p.154)

8

John Bellany born 1942

Born in Port Seton, near Edinburgh; studied at Edinburgh College of Art, 1960-5, and the Royal College of Art, London, 1965-8; included in *Young Contemporaries*, London, 1964-6. Retrospectives: Scottish National Gallery of Modern Art, Edinburgh and Serpentine Gallery, London, 1986; Hamburg and Dortmund, 1988-9; Glasgow, 1992; elected RA 1992.

Sir Peter Maxwell Davies, 1991 [illustrated p. 20]
Oil on canvas, 172.7 x 152.4 (68 x 60)
Scottish National Portrait Gallery

The huge corpus of humanist allegories which characterize John Bellany's thirty-year career has been punctuated at every point by significant portraits which in retrospect now seem to be the backbone of his art. Often the subjects (himself, his family, his friends), the mood of the portrait and its execution reflect the general state of his art at the time. Then boundaries become blurred; portraits appear in the allegories and current paintings and concerns appear in the portraits. A renewed optimism in Bellany's work which dates from around the time of the reunion with his first wife Helen in 1985 and which survived his brush with death several years later, seems to demand wide social contact and Bellany is quick to accept the bridge portraiture offers between his art and his social life. Several commissions for the Scottish National Portrait Gallery include this portrait of Sir Peter Maxwell Davies. The distinguished composer's eyes were a particular focus of attention for the artist and they dominate the centre of the work. The painting against the studio wall in the background is integrated into the portrait, and in counterpoint with the vigorous reds on the left becomes a metaphor for the composer's music of which the portrait is the visible celebration.

Ref: K. Hartley, *John Bellany, Paintings, Watercolours and Drawings 1964-86*, exh. cat., Scottish National Gallery of Modern Art, Edinburgh, 1986.

9

Tony Bevan born 1951
Born in Bradford, studied at Bradford, Goldsmiths' College and the Slade School of Art 1968-76; has shown in London from 1976 and to considerable acclaim in Europe and the USA from 1983. Solo exhibitions: ICA, London, 1987; Whitechapel Art Gallery, London, 1993.

Portrait Boy, 1990 [illustrated p. 73]
Acrylic on canvas, 67.3 x 54.6 (26 ½ x 21 ½)
The Artist

Characterized in 1993 by the art critic of *The Independent* as 'anti-portraiture' (a term the writer subsequently failed to explain), many of Bevan's paintings are nonetheless portraiture. Frequently (though not invariably) of himself or even of hands, a foot, a back or a neck, Bevan's insistence on a literal line, flat technique and total lack of incidental information or traditional painterly bravura focuses the viewer's undivided attention on the human subject. Such simplicity and directness, compounded by Bevan's use of a narrow range of strong emotive colours, have led to social, political and philosophical interpretations of his work not specifically endorsed by Bevan himself. Taken at face value, Bevan's figures are presented as individual aspects of humanity rather than victims of particular circumstances. This is particularly true of his unique series of portraits of children painted since 1988. Traditionally a minefield for the conventional portrait artist, Bevan's children are on the one hand universally recognisable as every small boy down the road, and at the same time - and rather mysteriously - as visual extensions of the artist's own personality.

Ref: *The Meeting, Tony Bevan*, exh. cat., Whitechapel Art Gallery, London, 1993.

10

Peter Blake born 1932
Born in Dartford, Kent; studied at Gravesend and the Royal College of Art, London, 1949-56; *On the Balcony* (1955-7, Tate Gallery) demonstrated his lifelong passion for collecting and using ephemera in his work; during 1960s a leading exponent of British Pop; founder member of the Brotherhood of Ruralists, 1975. Retrospective: Tate Gallery, 1983.

'The Meeting' or 'Have a Nice Day, Mr Hockney', 1981-3 [illustrated p. 53]
Oil on canvas, 99.2 x 124.4 (39 x 49)
Tate Gallery, presented by the Friends of the Tate Gallery out of funds bequeathed by Miss Helen Arbuthnot, 1983

This is one of Blake's largest and indeed most ambitious paintings, taking, with tongue in cheek, its model from Courbet's pseudo-didactic picture *Bonjour M. Courbet* (1854). As with Courbet, a campaigning figure whose contempt for intellectualism and convention Blake might well share, Blake's portraits of himself and fellow artists David Hockney and Howard Hodgkin are 'realistic' and the situation, though highly contrived, a faithful enough record of Hodgkin and Blake's trip to California in 1981. Like much of Blake's work however, it is imbued with affectionate irony and gently mocks the two distinguished pillars of British painting greeting the bohemian expatriate (brush and cigar in hand) in his adopted setting. The banal advertising and hideous beach architecture contrast with the crumbling pretensions of the Victorian picture frame, and the whole scene is inadvertently stolen by the skateboard girl.

Ref: Michael Compton, *Peter Blake*, exh. cat., Tate Gallery, London, 1983, no. 105.

11

Michael Clark born 1954

Born in Manchester; included in *Northern Young Contemporaries*, Whitworth Art Gallery, Manchester 1975, 1977; from 1977 frequented Colony Room Club, Soho; commissioned by Royal Society of Arts to paint HRH The Duke of Edinburgh, 1983. Solo exhibitions: Birch and Conran, London, 1988; Graves Art Gallery, Sheffield, 1989.

Vanitas (Lisa Stansfield), 1990-2 [illustrated pp. 26-27]
Oil on canvas (with wood, magnets, velvet and human organic material) 64.8 x 62.9
(25 ½ x 24 ¾)
The Artist

Recently in a search for a more conceptual approach to portraiture, Michael Clark has been experimenting with different formats, derived in part from his reading of medieval philosophy. A notable example is *Some May Lose Their Faith* (1993), a portrait of an unknown woman which includes paintings, photography and actual scraps of human material, but no facial likeness. *Vanitas*, a free-standing diptych with Rochdale-born singer Lisa Stansfield on one side and a meticulously painted bleeding breast on the other, was originally intended as part of an installation with sound and slide tape. The work however stands on its own as an elaborate allegory for a contemporary heroine, the format derived from a work of the same name by Barthel Bruyn the Elder. Between the two canvases is a scrap of paper with a quotation from the Mexican poet Octavio Paz: 'Estoy vivo en el centro de una herida todavia fresca' (I am living in the centre of a wound still fresh). Parallels with religious imagery and a corrective to the Pop world view of Lisa Stansfield are clearly intended. Other conclusions we are left to draw ourselves.

Ref: *Michael Clark, Paintings, Drawings and Prints 1977-88*, exh. cat., Birch & Conran Fine Art, London, 1988.

12

Francesco Clemente born 1952

Born in Naples; studied architecture in Rome; included in Venice Biennale, 1980; *Zeitgeist*, West Berlin, 1982. Solo exhibitions include: Whitechapel Art Gallery, London (and tour), 1983; Ringling Museum of Art, Sarasota (and extended USA tour), 1985-7; Madrid, 1987.

Julian Schnabel, 1981 [illustrated p. 45]
Fresco, 210.8 x 145 (83 x 57)
Anthony d'Offay Gallery, London

In an *oeuvre* as multi-faceted and eclectic as Clemente's, where the only constants seem to be the recurrent self-portrait and his own psychological obsessions, the series of portraits of the early 1980s are remarkable for their objectivity. Born in the same year, both artists burst on to the international art world in the late 1970s, and Schnabel's first 'plate' painting (cat. no. 54) appeared in 1979. In Clemente's portrait of the American prodigy, the surface relief of the plaster defines the composition and encloses it rather than defying and fracturing it à la Schnabel. Like much of Clemente's work it resists interpretation, its shapes, colours and symbols speak of refinement and culture, perhaps in a rather oriental way; it is an image of a young man at once tender and vulnerable and at the same time tensed for creative conquest.

Ref: Michael Auping, *Francesco Clemente*, exh. cat., New York, 1987; *Francesco Clemente, Affreschi*, exh. cat., Madrid, 1987, no. 44.

13
Chuck Close born 1940
Born in Monroe, Washington; studied at the University of Washington, Seattle, and Yale Schools of
Art; Academy of Fine Arts, Vienna, 1962-5. Solo exhibitions include: Museum of Contemporary Art,
Chicago, 1972; Pompidou Centre, Paris, 1979; Walker Art Center, Minneapolis, 1980-1; Columbia
Museum, South Carolina, 1983-4; Yokohama Museum of Art, Japan, 1989.

Bill, 1990 [illustrated p. 48]
Oil on canvas, 182.9 x 152.4 (72 x 60)
The Pace Gallery, New York

**Chuck Close has with the exception of one or two forays into photo-pieces remained loyal
to the format of the greatly enlarged, totally unadorned and contextless close-up.
Constructed on a grid and transposed section by section from his original photograph it is
a process described by Close as 'building it like I'm stacking bricks'. His art however has
not stood still and he has moved from the airbrush paintings with which he made his
name to dot drawings (in which ironically the descriptive information is omitted
altogether), fingerpaintings, pulp paper collages and the semi-divisionist work in oil paint
of which the *Self-Portrait* (1986) was the first. This variety of technical approaches, often
using the same image even after a period of years, emphasizes the conceptual nature
underlying Close's apprehension of portraiture. In *Bill*, a further modification is
appropriately used for a portrait of fellow New York artist William Wegman who has
notoriously used his dog in his own conceptual commentary. Using a diamond instead of
a square format for his grid, the small sections, some in twos and threes, contain
miniature abstract paintings, enjoyable in themselves, the diagonals of the grid creating
an almost cubist effect.**

Ref: L. Lyons & R. Storr, *Chuck Close*, New York, 1987.

14
Alex Colville born 1920
Canadian painter and printmaker, born in Toronto; sent to Europe as War Artist, 1944; taught at
Mount Alison University, Sackville, 1946-63; moved to Wolfville, Nova Scotia, 1973; recipient of
many Canadian honours, best known painting *Skater*, 1965 (Museum of Modern Art, New York);
represented in most major European and North American collections.

Couple on Bridge, 1992 [illustrated p. 58]
Acrylic polymer emulsion on board, 86.4 x 86.4 (34 x 34)
Courtesy the Drabinsky Gallery, Toronto

**Colville's work has changed little throughout his long career and for the last twenty years
he has continued to encapsulate the timeless poetry of his small corner of Nova Scotia
and its anonymous inhabitants. Totally at variance with conventional portraiture, the very
anonymity of Colville's figures underlines the significance of the individual in his or her
relationship both to the natural world and to the structure of the community in which he
or she lives. Although the paintings invariably depict a specific person, family, friend or
neighbour, the titles indicate sometimes no more than location (*Man on Verandah*, 1953),
time (*May Day*, 1970) or occupation (*Chaplain*, 1991). In most of these figure subjects,
atmosphere and mood play a more significant role in the resulting 'portrait' than specific
delineation of character or commentary by the artist. Colville himself and his family are
probably the most frequent models for his figures; in this typically meticulous
composition the artist and his wife, standing in for all long-married couples, pause on a
late afternoon walk to admire the view and talk out a current problem.**

Ref: D. Burnett, *Colville*, Art Gallery of Ontario, 1983.

15

Stephen Conroy born 1964

Born in Helensburgh, Scotland; studied at Glasgow School of Art, 1982-7; included in *The Vigorous Imagination*, Scottish National Gallery of Modern Art, Edinburgh, 1987; *The New British Painting* (toured 5 venues in America), 1988-90. Solo exhibitions: Marlborough Fine Art, London, 1989 (toured to Manchester and Glasgow), 1992.

His Grace the Duke of Devonshire, 1992-3 [illustrated p. 30]
Oil on canvas, 183.5 x 91.7 (72 ¼ x 36 ⅛)
Private Collection, England

The bravura, visual inventiveness, and sense of mystery which permeate the elaborate figure compositions with which Stephen Conroy so rapidly made his name have tended to divert attention from the acute observation and descriptive powers found in the small paintings of heads and rare larger portraits. His second commissioned work (the Scottish National Portrait Gallery was quick to take advantage of him with their 1990 portrait of Sir Steven Runciman), this private commission must rank as one of the most imposing formal portraits of recent years. The fact that the sitter had previously been painted by Lucian Freud can only have contributed to the challenge of the undertaking. In an impeccably post-modern composition the figure of the Duke rises, almost chillingly statuesque, in immaculately sculpted clothes. The use of reflected images in the library background creates a feeling of claustrophobia; the small attaché case sits like an unexploded bomb on the chair, heightening the sense of foreboding.

Ref: *Stephen Conroy*, exh. cat., Marlborough Fine Art, London, 1989 and 1992.

16

John Davies born 1946

Sculptor and draughtsman; born in Cheshire; studied at Hull and Manchester Colleges of Art, 1963-7; Slade School of Art, 1967-9; sculpture fellowship, Gloucester College of Art, 1969-70; winner of Sainsbury Award, 1970-1. Solo exhibitions: Whitechapel Art Gallery, London, 1972, 1975; Marlborough Fine Art, London, 1980, 1984, 1989, 1993.

Head Like D.Y., 1985-8 [illustrated p. 60]
Resin, fibreglass, stone dust and acrylic, 104.1 (41) high
Marlborough Fine Art (London) Ltd

John Davies' preoccupation with the human head has always centred around its archetypal and symbolic connotations rather than as the seat of self-expression or of the individual ego. Commissioned to sculpt a portrait of the collector Sir Robert Sainsbury, Davies concealed the face behind a mask, more in the spirit of making a statement about the paradox of creating a likeness than of conveying some psychological truth. Some of Davies' heads do however start off from likenesses of friends or family, indicated in the titles only by initials. Drawings, some very large like the 1984 drawing of D.Y. connected with the present work, map out inscrutably a thousand contours; but 'then the struggle is to make a head that simply works - regardless of keeping to strict appearances' (letter, 4 November 1992). The use of the word 'like' in the title of this and other works again implies a distancing from the original. This slightly ambivalent approach is mirrored in Davies' frequent choice of resin for his sculptures; despite its potential for greater realism than stone or bronze, Davies exploits resin in quite the opposite way, working, detailing, incising and colouring it so that the heads become metaphors for humanity rather than representations of it.

Ref: *John Davies*, exh. cat., Marlborough Gallery, New York, 1989, no. 43, ill. p.13; *John Davies, New Sculpture*, exh. cat., Marlborough Fine Art, London, 1993.

17
Jim Dine born 1935
Born in Cincinatti; from 1959 associated with Pop Art; a pioneer of happenings and performance art. Retrospective: Whitney Museum of American Art, New York, 1970; subsequently turned to more traditional art forms. Solo exhibitions include: Art Institute of Chicago, 1983; Contemporary Arts Center, Cincinnati (and tour), 1988-90; Albertina Museum, Vienna, 1989.

Large Portrait of Nancy (Study for a Sculpture), 1983 [illustrated p. 61]
Charcoal and enamel on paper, 139.7 x 102 (55 x 40 ⅛)
Private Collection

Working as thoroughly as any of the great academicians of the past, Dine draws, sketches and sculpts round his current theme and shows us not only the nuts and bolts of art but the drama of unexpected juxtapositions and intimations of mortality in symbols long buried in the subconscious. Portraiture has occasionally surfaced as a theme, not so much from the desire to describe other people close to him but rather as a fusion of subject and psychological tension, usually achieved by drawing. The portraits of his wife Nancy occupied him for several years concurrently with his preliminary exploration of the mythical power of the Venus de Milo. A number of large drawings, a series of etchings and various sculptures, some on rods, resulted from this project; the present work is in fact taken from a plaster sculpture of Nancy and is more stylised and worked than the drawings from life. One is reminded of Giacometti, who worked constantly from his wife, Annette; Dine's portraits share something of the Swiss master's sombre and inquisitory qualities, a reflection perhaps of the complete detachment which only long-sustained intimacy can bring about.

Ref: Constance W. Glenn, *Jim Dine, Drawings*, New York, 1985, pl. 162; *Jim Dine Drawings 1973-1987*, exh. cat., Contemporary Arts Centre, Cincinatti, 1988, no. 44, ill. p. 73.

18
Peter Edwards born 1955
Born in Chirk, North Wales; studied at Shrewsbury School of Art, Gloucestershire College of Art, 1974-8; exhibitor at Royal Academy, London, from 1980 and at Portrait Award, National Portrait Gallery, London, from 1981 (awarded third prize, 1985). Solo exhibitions include: *Contemporary Poets*, National Portrait Gallery, London (and tour), 1990.

Seamus Heaney, 1987 [illustrated p. 52]
Oil on canvas 61.2 x 51 (24⅛ x 20⅛)
Private Collection, Belfast

With a preference for large, set-piece portraits in which he can give full play to his exploration of light and movement and his sense of allegory, Peter Edwards's work seems to lie somewhere, if that is possible, between the twin influences of Bacon and Freud. His series of whole-length portraits of contemporary poets and the occasional commissioned portrait of an academic never lose sight however of that tradition of realism and intimacy in native British painting which seems to deny the grandeur of the grand manner. In the large portrait of Seamus Heaney the artist focused on details such as the slight impatience of a swinging hand, the polished shoes and ill-fitting loose-covers on the armchair, which add up to a monumental *tour de force* of realism, a tribute to one of the great literary figures of our time. This lyrical small sketch, one of several for the painting, reminds the spectator of the keen observation and grasp of essential truths which lie behind the creation of such a work.

Ref: *Contemporary Poets, Portraits by Peter Edwards*, exh. cat., National Portrait Gallery, London, 1990.

19

Rainer Fetting born 1949

Painter and sculptor, born in Wilhelmshaven, West Germany, lives and works in Berlin and New York; studied at the Academy of Art, Berlin, 1972-8; co-founder of Galerie am Moritzplatz, 1977. Solo exhibitions: Museum Folkwang, Essen, 1986; Museo di Barcelona, 1989; Nationalgalerie, Berlin/GDR, 1990.

Selbstportrait als Rembrandt am Leninplatz (Self-portrait as Rembrandt on Lenin Square), 1991 [illustrated p. 83]
Oil on canvas, 250 x 140 (98 ½ x 55 ⅛)
Raab Boukamel Galleries Ltd and Rainer Fetting

The label, neo-Fauve (*Neue Wilde*) seemed to sit easier on Fetting than on the other artists of his circle, for like the original Fauves, his work and life both in Berlin and New York have an air of cosmopolitan glamour and excitement. These qualities are particularly apparent in the large-scale and striking portraits which depict a wide range of friends from around the world, academics and curators, beautiful women and men in drag. The political edge characterized by his early paintings of the blankness of the Berlin wall was, however, almost obligatory for German artists of his generation, and the wall crops up again in his work in 1987. Fetting watched the fall of the wall on television in New York but by the end of the year had returned to explore the former GDR. The Leninplatz had been the heart of communist East Berlin, and Fetting uses the statue as a monolithic emblem of the old totalitarian state. In this context, Rembrandt provides an apt if affectionately ironic emblem of the triumph of the individual and for Fetting himself of a return to the roots of both his re-unified country and his art.

Ref: *Rainer Fetting, Berlin/New York, Gemälde und Skulpturen*, exh. cat., Staatliche Museen zu Berlin, 1990

20

Stephen Finer born 1949

Solo exhibitions: Anthony Reynolds Gallery, London, 1986, 1988; Berkeley Square Gallery, London, 1989; Bernard Jacobson Gallery, London, 1992. Selected by R. B. Kitaj for *Academician's Choice*, Eye Gallery, Bristol, 1990.

Marlene Dietrich, 1988 [illustrated p. 23]
Oil on canvas, 31 x 25 (12 ¼ x 9 ⅞)
Private Collection

For a painter whose work is usually identified by tersely-worded titles such as *Woman of seventy-three*, it may seem quixotic to include here a portrait of a woman of eighty-seven (?) whose features are known the world over. Finer's normal working methods resemble those of Auerbach (cat. no. 3) - long hours in the studio in front of professional models or close friends, in which paint slowly accumulates on canvas and is worked and reworked to create an image which finally corresponds to the artist's experience of the other person. Unlike Auerbach, however, Finer's work has so far been totally confined to the head or the figure, though his slowly evolving *oeuvre* suggests a similar search for new ways of enlarging a highly personal vocabulary. A meeting and a chance to observe Dietrich supplied the motive for this departure from his normal practice. Pale colours and delicate, sparkling staccato brush-work give an air of fragility to this exquisite small painting, a new response for Finer to a new situation. The immediate experience of the ageing diva mingles with the thousand film clips which over the century have become part of our visual heritage.

Ref: *Stephen Finer*, exh. cat., Berkeley Square Gallery, London, 1989, ill.

21

Lucian Freud born 1922

Born in Berlin; came to England, 1932; studied at the Central School, under Cedric Morris and Lett Haines at Dedham, and at Goldsmiths' College 1938-43; first exhibited Lefevre Gallery, 1944; won Arts Council Prize, Festival of Britain, 1951; exhibited with Ben Nicholson and Francis Bacon, Venice Biennale, 1954. Retrospectives: Hayward Gallery, London, 1974, 1988 (British Council tour including Washington, Paris and Berlin); Whitechapel Art Gallery, London, 1993.

Painter and Model, 1986-7 [illustrated p. 51]
Oil on canvas, 159.6 x 120.7 (62 ¾ x 47 ½)
Private Collection

The authority and consistency of Lucian Freud's mature work makes it difficult for us to view it in any context other than his own. The squalor and general tattiness of the studio, the casual nudity and smell of warm bodies, the air if not of defeat at least of resignation - all these things we accept without reservation although most of the situations presented to us by Freud's paintings are as far removed from our own daily experience as Hockney's suburban California. Despite its insistent realism the couple in *Painter and Model* seem to act out an ironic allegory of Freud's art. The usual roles suggested by the title are reversed: the painter is a woman (Celia Paul), the model a man (Angus Cook). The painter however, despite all the evidence of brushes and paint, is not painting and has no canvas. In effect, she has assumed Freud's role in the proceedings and has moved round in front of the canvas, brush in hand, possibly to check something, but more likely it seems to pursue a point in an exhausting argument at the end of a long night. In the process, she treads on a tube of paint, an unusually incidental detail in a Freud painting - but isn't that, he seems to be saying, the root of the whole business anyway?

Ref: Robert Hughes, *Lucian Freud: Paintings*, ex. cat., British Council, London, 1987, ill. no. 99.

22

Elisabeth Frink 1930-93

Sculptor; born in Thurlow, Suffolk; studied at Guildford and Chelsea Schools of Art, 1947-53; numerous public commissions include *Eagle* for J. F. Kennedy memorial, Dallas, Texas, 1964; illustrated various classics, including Homer's *Iliad*, 1975. Retrospective: Royal Academy, London, 1985. Created DBE, 1982.

Self-portrait, 1987 [illustrated p. 87]
Bronze, 45.7 high (18)
Elisabeth Frink

'I have no interest in sculpting female figures at all', Elisabeth Frink told Norman Rosenthal in 1985.* This self-portrait is almost unique in the work of an artist whose reputation is based on intense explorations of masculinity, and bears perhaps a tenuous link only with her *Walking Madonna* (1981) for Salisbury Cathedral. Her sleek male heads, whether of anonymous figures or commissioned portraits (like *Sir Alec Guinness*, 1983, National Portrait Gallery) bear a strong family relation to one another; her self-portrait, with its heavy thatch of hair and dense coloured patinas, is a complete contrast. Elisabeth Frink refuted Rosenthal's suggestion that her male figures embodied aspects of herself, conceding only that without a model, an artist inevitably makes use of her own expressions. The singularity of the self-portrait seems in a way to confirm her assertion: its gaze has a specific introspective quality quite foreign to her other work. (HC)

Ref: *Elisabeth Frink: Sculpture*, exh. cat., Royal Academy of Arts, London, 1985 (*quoted p.27)

23

Sighard Gille born 1941

Born in Eilenburg, near Leipzig; studied at the School of Graphic Art, Leipzig, 1965-70; master pupil of Bernhard Heisig in Berlin, 1974-6; from 1972 in group exhibitions of work from the GDR including London (Barbican, 1984); painted ceiling of new Gewandhaus concert hall, Leipzig, 1980-82. Retrospective: Städtische Galerie, Oberhausen, 1989.

Gala and Dali, 1982/3 [illustrated p. 22]
Mixed media on hardboard, 110 x 90 (43 ¼ x 35 ½)
Ludwig-Collection Oberhausen, Germany

By the early 1970s Sighard Gille, who had trained as a photographer and come late to painting, was being associated with the group of younger artists whose work was patently critical of everyday life in the GDR. On the whole uninterested in the grand historical themes of the previous generation, he made his name as a painter of social gatherings, domestic situations and in particular of a remarkable group of double portraits of friends and contemporaries. Gille's keen sense of irony, bordering on caricature, is emphasized by his inspired use of colour, frequently recalling Kokoschka. Here the irony is mingled with respect for the ageing Spanish master and his wife Gala, who died during the conception of the portrait. The portrait is a devastating study of the tenacity of old age, the almost animal-like grip on life tempered by the sombre colours of the couple's fantastic clothes.

Ref: *Sighard Gille 1962-1989*, exh. cat., Städtische Galerie Schloss Oberhausen, 1989, no. 278, ill p. 61.

24

Leon Golub born 1922

Born in Chicago; studied at the Art Institute of Chicago, 1946-50; Professor, Livingston College, Rutgers University, 1964; from mid-1960s produced series such as *Gigantomachies*, *Vietnam* and *Mercenaries*. Retrospectives: Temple University, Philadelphia, 1964; New Museum of Contemporary Art, New York (and tour) 1984-5; Stockholm 1992-3.

Head I, 1989 [illustrated p. 72]
Oil on canvas, 71 x 58.5 (28 x 23)
Anthony Reynolds Gallery, London

In an extraordinary series of portraits dating from the mid-1970s, Leon Golub painted a number of heads of world leaders ranging from Chou-En Lai to Pope Paul. Conventional portraits of men of power traditionally reinforce our image of their position in society; Golub's portraits, however, derived from candid news shots taken off-guard and painted on unframed, unprimed scraps of canvas, could be seen almost as an indictment. Equally political are the large paintings of urban violence and tension with which Golub has made his name since then. Derived in the same way from his huge collection of newspaper clippings, these may also be seen as portraits, but of the anonymous perpetrators and victims of violence in the contemporary world. The contrast between the extreme refinement and beauty of Golub's technique and the unpalatability of his subject matter has often been commented on, but the very beauty of his paintings demands our attention for the underside of modern life. Painted alongside the series of mercenaries, lynch mobs and racial confrontations, the small heads such as this one are a moving critique of the dehumanizing effects of violence and poverty. But abuser or abused? The borderline, Golub reminds us, is seldom clear.

Ref: Gerald Marzorati, *A Painter of Darkness, Leon Golub and our Times,* New York, 1990; Leon Golub Paintings/Målningar Retrospektivt, exh. cat., Malmö, 1992.

György Gordon born 1924
Born in Hungary; studied at the Hungarian Academy of Fine Art, Budapest, 1948-53; fled Budapest during the National Rising, 1957; worked as graphic artist in London until 1964; lecturer, Wakefield College of Art, 1964-86. Solo exhibitions: Salford City Museum and Art Gallery, 1972; Wakefield City Art Gallery, 1974. Retrospectives: Leeds City Art Gallery 1989; National Széchényi Library, Budapest, 1992.

Peter Cropper, 1991 [illustrated p. 50]
Oil on canvas, 45 x 46 (17 ¾ x 18 ⅛)
Peter Cropper

Many of Gordon's most memorable paintings have been images of human suffering and self-doubt derived in part from his wartime experiences as a stretcher-bearer and in part from his assimilation of a diversity of sources such as Kafka and Francis Bacon. Since the later 1980s, however, his work has shown a new mood of optimism, an interest in other people and a strong sense of the possibilities of light in the delineation of character and mood where, earlier, distortion, simplification or shadow might have been used. The first sketches of Peter Cropper, violinist and leader of the Lindsay Quartet, were originally made in connection with research for illustrations to Friges Karinthy's *The Circus* (1989). There may be an echo in this intense but over life-size painting of some of Gordon's earlier heads with closed eyes, but it is evidently his fascination with Peter Cropper's extraordinarily expressive features and total involvement in his playing from which the composition is evolved. Gordon omits the violin, the source of sound, but leaves us in no doubt as to the source of the music.

Ref: George T. Noszlopy *György Gordon*, Otley, 1989; *György Gordon: A Retrospective Exhibition*, exh. cat., National Széchényi Library, Budapest, 1992, no. 61, ill. p. 79.

26
Anthony Green born 1939
Born in London; studied at the Slade School of Art, 1956-60; won French Government scholarship and lived in Paris, 1960-1. Solo exhibitions include: City Art Gallery, Birmingham, 1978; Perth Museum (Scottish Arts Council tour), 1984; Sainsbury Centre for the Visual Arts, University of East Anglia, 1989.

Framlington Group, 1986 [illustrated p. 32]
Oil on board, 182.9 x 215.9 (72 x 85) irregular
Tim Miller

When Anthony Green's *Framlington Group* was exhibited at the Royal Academy in 1986 it seemed to herald a dazzling change from the inherent stuffiness (or occasional cosiness) of so many corporate portrait commissions. A vivid painting full of life and keen observation, it had also achieved the impossible and made city businessmen and an eighties office look interesting. It is, of course, Green's eye for the minutiae and foibles of daily life, normally restricted to his own domestic arrangements, that transforms a potentially lethal subject into a joyous celebration of the basically ordinary. As in the many paintings of himself and his wife, the surface humour credibly conceals deeper truths. The typical eccentrically shaped board, ideally formed for the arid rectangularities of the modern office, even made provision for portraits of further directors to be bolted on in the future. Sadly the triumvirate of Bill Stuttaford (left), Tim Miller (centre) and Antony Milford (right) was broken when the company was taken over two years later; seven years later we are still waiting for a new era of corporate portraiture - and Anthony Green for another commission.

Ref: Anthony Green, *a green part of the world*, London, 1984.

27

Maggi Hambling born 1945

Born in Sudbury, Suffolk; early studies with Lett Haines and Cedric Morris at Hadleigh; began painting portraits, 1973; first artist in residence at National Gallery, London, 1980-1; *Max Wall* pictures at National Portrait Gallery, London, 1983. Solo exhibition: Serpentine Gallery, London, 1987. Recent work includes series of *Sunrises*, *Laughs*, prints and ceramic sculpture.

Sir Georg Solti conducting Liszt's 'A Faust Symphony', 1985 [illustrated p. 34]
Oil on canvas, 121.9 x 121.9 (48 x 48)
Private Collection, London

Originally invited in 1983 by Lady Solti to paint the distinguished conductor, Hambling only took up the idea two years later in 1985 and arrangements were made for her to attend rehearsals at St John's, Smith Square, and at the Royal Festival Hall. There Hambling made a series of charcoal drawings, finally seeing her subject in evening dress for the first time at the concert itself on 27 October. Without sittings, circumstances demanded a more imaginative approach. Portraits are only one facet of Hambling's art and just as the *Sunrise* series which began that April was as much an attempt to paint the spirit of the phenomenon as its physical beauty and colour, the portrait of Solti is a rendering of the often demonic music of Liszt's 'Faust Symphony' through the genius of its interpreter and the paint and colour of Hambling's brush. In retrospect the artist remembered that she had only been able to continue painting while the music was still running through her head. On seeing the portrait for the first time, Solti is reported to have said: 'Very good ... You have painted the devil's brother.'

Ref: *Maggi Hambling: Paintings, Drawings and Watercolours*, exh. cat., Serpentine Gallery, London, 1987; Judith Bumpus, 'Sir Georg Solti by Maggi Hambling' in programme of *Fortieth Aldeburgh Festival of Music and the Arts*, 1987, pp. 112-3, ill. p. 99.

28

Richard Hamilton born 1922

Born in London; founder member of the Independent Group at the ICA, London, 1952; contributor to *This is Tomorrow* exhibition, Whitechapel Art Gallery, London, 1956 and leading figure in Pop Art movement; his painting, prints and multi-media works have continued to provide a succinct commentary on contemporary cultural issues and styles. Retrospectives: Tate Gallery, 1970, 1992.

Northend I, 1990 [illustrated p. 59]
Oil on cibachrome on canvas, 100 x 109.5 (39 ⅜ x 43)
The Artist, courtesy of the Anthony d'Offay Gallery

Like the 1976 painting *Langan's* produced for the restaurant of that name, *Northend I* combines a photographic image of a particular interior in an earlier unrefurbished state with a painted image which relates, ironically, more directly to what the viewer can actually see. When the *Langan's* painting was removed from its site in the restaurant, Hamilton's wife, the painter Rita Donagh, encouraged him to repeat the idea of a painting which included a view of the interior in which it was to be hung. This basically simple but imaginative concept develops themes found throughout Hamilton's *oeuvre*: the working together of disparate elements (decay and life, painting and photograph); the framing devices of doorway and ceiling and the slightly theatrical air of 'action unfolding' noticed by Richard Morphet. The elegant figure of Rita Donagh posed momentarily in the crumbling interior (here for all the world like an Antonioni heroine) echoes the *Interiors I* and *II* of 1964 which were inspired by a film still of an earlier vintage. Like many a portrait sitter before her, Rita Donagh was unhappy with her presence in the painting and Hamilton made a second version, *Northend II*, substituting a table which had been a gift from her and a vase of bluebells for the figure.

Ref: R. Morphet with S. Maharaj, D. Mellor & S. Snoddy, *Richard Hamilton*, exh. cat., Tate Gallery, London, 1992, no. 91.

29

Bernhard Heisig born 1925

Born in Wroclav (Breslau), Poland; studied at Breslau, 1941-2; Leipzig (1949-51); Director of School of Graphic Art and Printing Design, Leipzig (1961-4, 1976-87); exhibited widely in GDR and abroad. Solo exhibitions include: Leipzig Museum, 1966; Staatliche Kunstsammlung, Dresden, 1973. Retrospective: Berlin, Bonn, Munich, 1989-90.

Chefchirurg (Chief Surgeon) Dr Mättig, 1989-90 [illustrated p. 64]
Oil on canvas, 110 x 90 (43 ¼ x 35 ½)
Dr Heinz Mättig, Wiederitzsch

The need to create a valid alternative to Soviet Socialist realism within the political framework of the GDR led to a strong historical vein in Heisig's work and his virtuoso allegories are painted in a style which has its roots in Corinth, Kokoschka, Beckmann and Dix, and further back in Grünewald and the artists of the German Gothic. Parallel to these runs a masterly series of portraits: sitters have included former Chancellor Helmut Schmidt (1983-4) and art patron Peter Ludwig. This portrait of Heisig's friend Dr Mättig was included in the artist's retrospective exhibition in Berlin in 1989 and was subsequently almost entirely repainted. This apparently not infrequent dissatisfaction with his work (witness the multiple dates for other works in the catalogue for that exhibition) casts light on Heisig's ongoing involvement with the subject matter of his art. In the case of *Dr Mättig*, the changes appear to have transformed the portrait from a relatively genial image of a friend in repose to a far more psychologically alert representation of the professional at work.

Ref: Jörn Merkert & Peter Pachnicke, *Bernhard Heisig Retrospektive*, Munich, 1989, no. 119, ill.

30

David Hockney born 1937

Born in Bradford; studied at the Royal College of Art, London, 1953-62; *A Rake's Progress* etchings, 1963; moved to Los Angeles, 1964; began *Swimming Pool* paintings, 1964; designs for Glyndebourne, Metropolitan, and Los Angeles Operas from mid-1970s; developed photo-based works from 1976. Retrospectives: Whitechapel Art Gallery, London, 1970; Los Angeles, New York, and Tate Gallery, London, 1988-9.

Peter Langan, 1984 [illustrated p. 33]
Oil on eight separate canvases, 142.2 x 94 (56 x 37)
Courtesy of David Hockney. Collection of the Artist

Hockney's art has been driven by a constant search for new means of expression, manifested both in the exploration of new media and in the quest for new forms to convey old realities. A preoccupation with Cubism and the genius of Picasso runs parallel with the photo-composites. Portraiture appears as a constant *leitmotif* throughout his work. The intimate *Celia*, also of 1984, was painted in a modified version of a thirties Picasso, only the stylized curve of the arm indicating the possible source. In the portrait of restaurateur Peter Langan the head is based on a 'two-faced' Picasso, the small black and white canvas adjacent ironically providing a diagram of Langan's profile not altogether deducible from the main head. The other canvases are painted in a relatively straightforward manner, each providing further information about the sitter, but though assembled in a logical manner, they never quite add up. As with many great works of art, the sum of the whole is greater than its constituent parts. The affectionate distortion of the portrait is echoed by the irony inherent in the format; most of us, the artist seems to be saying (perhaps especially Peter Langan) are an idiosyncratic assembly of uneven parts.

Ref: Maurice Tuchman & Stephanie Baron, *David Hockney: A Retrospective*, exh. cat., Los Angeles County Museum, California, 1988.

31

Howard Hodgkin born 1932

Born in London; studied at Camberwell and Bath Academy of Art, 1949-54; taught at Charterhouse School, Bath Academy of Art and Chelsea School of Art, 1954-72. Solo exhibitions include: Tate Gallery, 1982; Venice Biennale, 1984 (and subsequent tour). Winner of the Tate Gallery Turner Prize, 1985. Knighted 1992.

Mr and Mrs James Kirkman, 1980-4 [illustrated p. 70]
Oil on wood, 103.5 x 121.3 (40 ¾ x 47 ¾)
Sue and David Workman

Hodgkin and Auerbach are both concerned with the slow and careful transliteration of people and places through the alchemical qualities of paint. Both are perfectionists who rework and discard; but there the similarity ends. Where Auerbach's paintings are the product of long and intimate contact and shared experience, Hodgkin's are almost Proustian affairs, the recollection of a specific event, with or without people. People figure far more frequently in Hodgkin's work than might appear to the casual observer. Apart from one or two early paintings such as the *Mr and Mrs Robyn Denny* (1960) where more conventional ideograms and shapes identify the subjects, their presence is often only indicated in the title by an address or an occasion. This portrait of the London art dealer and his wife records a dinner party; clearly a festive occasion, the intimate viewpoint vividly suggests those headless views of fellow guests obtained across the table whilst eating. Sparkling artificial light, a necklace, pendant, earrings, husband engaged in animated conversation; this is the impressionism not of the eye, but of the memory.

Ref: *Howard Hodgkin: Forty Paintings 1973-84*, exh. cat., Whitechapel Art Gallery, London, 1984, ill. p. 81.

32

Jean Hucleux born 1923

Born in Chauny, France; Venice Biennale 1976; has participated in numerous photo-realist exhibitions such as *Ekstrem Realism*, Louisiana Museum, Denmark, 1973; and portrait-based exhibitions such as *Le Visage dans l'Art Contemporain*, Musée du Luxembourg, Paris, 1990; also produces abstract drawings and sculptures.

Self-portrait No. 4, 1992-3 [illustrated p. 84]
Graphite on paper mounted on stretched canvas, 195.7 x 148.5 (77 x 58 ½)
The Artist, courtesy Loic Malle Fine Arts, Paris

Hucleux achieved fame in the 1970s firstly as a hyper-realist at *Documenta V*, Kassel, in 1972 and soon after with his extraordinary portrait of the collectors Irene and Peter Ludwig (1975-6). He has often been exhibited with Chuck Close since both artists became known for large-scale portraits transcribed from photographs, but they have otherwise little in common. A preoccupation with mortality already evident in Hucleux's early series of paintings of graveyards (1971-6), is inherent in his detailed dialogue with the photograph, which is after all only a momentary fragment of the past. This was emphasised by Hucleux's change from the use of paint to graphite in 1985 and the series of portraits mostly of dead artists and writers which followed. *Self-portrait No. 4* takes this a stage further and, working from his own photograph, the artist presents a *memento mori* for his life. The artist is seen in his studio in 1992, apparently working on the early (unnumbered) self-portrait painting of 1974. In the background is his portrait of Mondrian acquired by the Centre Georges Pompidou the previous year. A drawing of a photograph of drawings of photographs - the wheel of paradox in Hucleux's art has turned full circle.

Ref: *Jean Hucleux*, exh. cat., Galerie Montaigne, Paris, 1991.

33

Jörg Immendorff born 1945

Born in Bleckede, near Lüneburg; studied stage design, and under Beuys (1964) at Düsseldorf; taught art at secondary school, Düsseldorf, 1968-80; met A. R. Penck in (East) Berlin 1977; designs for *Elektra* for Bremer Theatre, 1986. Solo exhibitions throughout Europe, New York and New Zealand. Retrospectives: Osaka (Hong Kong and Seoul); Rotterdam and The Hague, 1992.

Café de Flore, 1990-91 [illustrated pp. 76-77]
Oil on canvas, 300 x 400 (118 x 157 ⅜)
Private Collection

Immendorff's political consciousness reached its peak in the *Café Deutschland* series begun in 1977 but has since then gradually given way to more personal and aesthetic concerns. The *Café de Flore* of which this is the largest version, is named after the Parisian café where artists and intellectuals met in the blackout during the Second World War. Immendorff postulates a microcosm of creative personalities, an allegory for the culture of his time, still (witness the chaotic scenes on the drawn blinds) sensed as a culture under siege. Immendorff himself appears throughout the painting often as a waiter, offering metaphoric potatoes, serving drinks, sweeping up dross. The artist has stressed the relative unimportance of the iconography, but once the spectator has spotted Schwitters and Beuys picked out in green it is difficult not to continue the teasing game of 'I Spy'. The artists Lüpertz, Penck, Baselitz, Ernst, Duchamp, Picabia and de Chirico, and other friends and cultural heroes, are all there. A strange blend of sublime comic strip and expressionist theatre, the living and the dead, the real and the symbolic, the *Café de Flore* is as magical and as thought-provoking as a Gothic altarpiece.

Ref: *Immendorff*, exh. cat., Museum Boymans-van Beuningen, Rotterdam and Haags Gemeentemuseum, Den Haag, The Netherlands, 1992, ill. pp. 112-3.

34

Allen Jones born 1937

Born in Southampton; studied at Hornsey and the Royal College of Art, 1955-61; secretary of the *Young Contemporaries*, 1961; two-man exhibition with Howard Hodgkin, ICA, London, 1962. Solo exhibitions from early 1960s in Europe and USA and from mid 1970s in Australia, Canada and Japan. Retrospective: Walker Art Gallery, Liverpool (English and German tour), 1979.

Sir David Wilson, 1991 [illustrated p. 17]
Oil on canvas, 152.8 x 91.5 (60 ¼ x 36)
The Trustees of the British Museum

Allen Jones is constantly confounding our conventional view of his work as the painter *par excellence* of sexual fetishism, and having produced some of the most interesting sculpture of recent years, he also seems set to undertake portraiture with similar resourcefulness and invention. It is easy to forget that Jones's first major paintings such as *The Artist Thinks* (1960) were in fact self-portraits and that the schematized self-portrait developed in these occurs regularly throughout his paintings of the sixties; the extraordinary *Leopard Lady* (1976) was also a portrait commissioned by the subject of the painting. It was nevertheless a bold and imaginative gesture on the part of the British Museum to commission Jones, one of their Trustees, to venture apparently well outside his perceived range. The retiring Director of the British Museum confronts the viewer aggressively though in characteristic stance, anchored in the sea of blue by the architect's drawing of part of the Museum.

Ref: Marco Livingstone, *Allen Jones, Sheer Magic*, London, 1979.

35
Panayiotis Kalorkoti born 1957
Born in Cyprus; studied at Newcastle University and the Royal College of Art, 1976-85; artist in residence, Leeds Playhouse, 1985; Netherlands Government Scholarship, 1986-7; Visual Arts fellowship, Newcastle University, 1988. Retrospective: Imperial War Museum, London, 1990. Artist in residence: Cleveland County, 1992 (exhibition Middlesborough and Amsterdam).

Woman with Cigarette, 1989 [illustrated p. 78]
Multi-plate etching, 76. 2 x 56.5 (30 x 22 ¼)
The Artist

Like Tony Bevan, Kalorkoti is profoundly involved in portraiture of the individual but presents it in simplified form to speak for humanity in general. Kalorkoti's imagery is more diverse than Bevan's and often blatantly didactic, incorporating specific references from news clippings or whatever is relevant at the time. Like Bevan he never identifies his subjects except perhaps by profession to place them within the relevant social order. *Woman with Cigarette* was the first of eight large prints to result from Kalorkoti's official commission for works of art for the National Garden Festival at Gateshead (1990). Five sketchbooks with 225 portraits were completed between September and January (adding to the many hundreds he has drawn since his student days) and were the raw material for his virtuoso and gravely beautiful use of the graphic medium. The oak leaf motif here recalls the involvement of the National Trust in the Garden Festival; the woman we have met before, though we never knew her name (she has probably given up smoking by now).

Ref: R. A. Wollen, *Panayiotis Kalorkoti, National Garden Festival Commission*, exh. cat., Gateshead, 1990, no. 8, ill p. 12.

36
Alex Katz born 1927
Born in New York; studied at Cooper Union Art School, New York and Skowhegan School of Painting and Sculpture, Skowhegan, Maine, 1946-50; first solo exhibition Roko Gallery, New York, 1954. Retrospective: Whitney Museum of American Art, New York (and tour to Miami), 1986.

Eric and Peter, 1991 [illustrated p. 46]
Cut-out, oil on aluminium, 183.5 x 96.5 x 29.2 (72 ½ x 38 x 11 ½)
Courtesy Robert Miller Gallery, New York

Cut-outs have featured in Katz's work since 1959 when, to solve a compositional problem he cut the figures out of a painting and mounted them on plywood. A double double-sided portrait of his most frequent model, his wife Ada, is one of the earliest results of the experiment. Katz evolved his art in the teeth of the New York School of abstract expressionism, which he both acknowledged and rejected, and is better known for his large-scale, or 'billboard' paintings, which convey their mood and atmosphere primarily through colour and the broad arrangement of shapes on a flat plane. Such two-dimensional depiction of the human form however is peculiarly well adapted to exploiting the visual opportunities and humour afforded by the cut-out. Like all Alex Katz's subjects, Eric and Peter are part of his social world: Eric Boman is a photographer and Peter Schlesinger best known as the model for many of David Hockney's paintings. It is impossible not to respond to these life-size figures. They invade our immediate world and we inadvertently become a part of the artist's long-running chronicle of contemporary life. And yet, though Eric and Peter seem to be 'there' from front and back, sideways on they disappear. (HC)

Ref: Sam Hunter, *Alex Katz*, New York, 1992.

37
R. B. Kitaj born 1932
Born in Cleveland, Ohio; served as a merchant seaman before studying in New York, Vienna, Oxford and finally at the Royal College of Art, 1960-2; immediate success with first solo exibition, Marlborough Fine Art, London, 1963; organized *The Human Clay*, Hayward Gallery, London, 1976. Retrospective: Hirshhorn Museum, Washington DC (and tour to Cleveland and Düsseldorf), 1991-2.

The Neo-Cubist, 1976-87 [illustrated p. 44]
Oil on canvas, 177.8 x 132.1 (70 x 52)
Marlborough Fine Art (London) Ltd

Both Kitaj and Hockney (cat. no. 30) have long been interested in the formal possibilities of Cubism and in the title of this portrait of Hockney, Kitaj makes gently ironic reference to Hockney's photomontages and other neo-cubist works of the period. What had begun life as a nude portrait in 1976 was resuscitated in 1987 after the death of Hockney's friend, Christopher Isherwood with, as Kitaj has said, 'Isherwood dislocating Hockney's form ... The egg shape is my mimicry of that grey Cubist ellipse which sometimes frames classical analytic Cubist compositions'. It also resembles the mystic *mandorla* enclosing the Virgin in medieval images, and rather movingly suggests a protective cocoon round the affectionate and very recognizable portrait of Kitaj's friend. Beyond the cocoon is the hot sultry world of California, the lush vegetation bursting with sexual energy and phallic growth.

Ref: Marco Livingstone, *Kitaj*, London, 1992, no. 422, ill. pl. 161.

38
Jeff Koons born 1955
Born in York, Pennsylvania; studied at the Maryland Institute, Baltimore, and the Art Institute of Chicago, 1972-6; moved to New York, 1976; exhibition *The New*, New Museum of Contemporary Art, 1980; married Ilona Staller ('La Cicciolina'), 1991; created *Puppy*, Arolsen, Germany, 1992. Major exhibitions in 1992/3: San Francisco and Minneapolis; Amsterdam and Stuttgart.

Self-portrait, 1991 [illustrated p. 88]
Marble, 95.3 x 52 x 36.8 (37 ½ x 20 ½ x 14 ½)
Anthony d'Offay Gallery, London

If Jeff Koons' self-appointed Duchampian role suddenly seemed to shift its concerns from mass-consumerism to sex with the *Made in Heaven* series in 1989, it was at least a sign of humanity in an approach that until then had seemed almost chillingly calculated. The self-evident if unconventional search for self-knowledge in the sexual pictures with Ilona went hand-in-hand with an exploration of the wider possibilities of cultural eclecticism ('I use modernism as metaphor for sexuality without love ... I played this off the Post-modern. Sex with love is a higher state'). The self-portrait of 1991 comes out of the sexual (post-modern) images, apparently from a photograph of the artist, nipples erect, at the point of orgasm. Neither classical nor *belle époque* as the use of marble might imply, Koons presents himself as the superman of post-modern art, the clustered stalagmites reminiscent of the crystalline birthplace of the comic-strip hero, elemental and phallic in their upward thrust. 'My art and life are totally one. I have everything at my disposal and I'm doing what I want to do. I have my platform, I have the attention, and my voice can be heard. This is the time for Jeff Koons.'

Ref: *The Jeff Koons Handbook*, London, 1992, ill. p. 121; *Jeff Koons*, exh. cat., San Francisco Museum of Modern Art, 1992, no. 52, ill.

39
Leon Kossoff born 1926

Born in London; studied at St Martin's School of Art and, with Frank Auerbach, under David Bomberg at Borough Polytechnic, 1949-53; Royal College of Art 1953-6. Solo exhibitions include: Beaux Arts Gallery, London 1957; Whitechapel Art Gallery, London, 1972, and *Paintings 1970-80*, Museum of Modern Art, Oxford, 1981.

John Lessore, 1992 [illustrated p. 49]
Oil on board, 104 x 78.8 (41 x 31)
Anthony d'Offay Gallery, London

Whereas Auerbach's paintings appear to be the products of a hard-fought search for truth through the medium of paint on the canvas, Kossoff's seem perhaps more like a struggle to retain that truth against the overwhelming power of the paint. In this context, American abstract expressionism is commonly cited as a parallel to Kossoff's work, though pure abstraction is as far removed from his intentions as photographic realism. Kossoff first painted John Lessore, a fellow artist and son of his original dealer and champion, Helen Lessore, in 1961 for the portrait now in the Tate Gallery. As is usual for Kossoff the dark lines define the presence of the sitter against the near-monochrome structure of paint. The local colour of clothes, flesh and chair, and the excitement of the Pollock-like drips on the portraits of *Chaim* of a few years earlier are entirely suppressed, leaving the sitter almost naked and vulnerable. Whether the all-pervading ochres suggest a mood or a feeling, or whether more practically they represent sittings under artificial light, is not entirely clear. The step-like figurations to the right of the sitter define the spatial depth of the room in which Lessore sits; the window gives a glimpse of the daylight and suggestion of colour denied to the portrait.

Ref: David Elliott, *Leon Kossoff: Paintings from a Decade*, exh. cat., Oxford, 1981; *Leon Kossoff*, exh. cat., Anthony d'Offay Gallery, London, and Robert Miller Gallery, New York, 1988.

40
Markus Lüpertz born 1941

Born in Liberec, Bohemia; fled 1948; intermittent studies at Krefeld and Düsseldorf, 1956-63; moved to Berlin, 1963; co-founder of Galerie Grossgörschen in Berlin, 1964; professor since 1976 at Karlsruhe and since 1986 at Düsseldorf. Major solo exhibitions: Munich, 1986; Rotterdam, 1987 and Madrid, 1991.

Selbstportrait, 1983 [illustrated p. 89]
Oil on canvas, 162 x 130 (63 ¾ x 51 ¼)
Courtesy Galerie Michael Werner, Cologne and New York

The eclectic nature of Lüpertz's imagery and apparently random use of stylistic conventions and emotive objects has links with American Pop and is perhaps more readily accessible than the work of his colleagues Baselitz (no. 7), Immendorff (no. 33) and Penck (no. 47). Sculpture is integral to his art and constant cross-references from painting to sculpture and vice versa abound. In *Selbstportrait mit Bildung* (Self-portrait with form, 1984), an ethereal and naked but very recognizable self-portrait is threatened by an all-too-solid sculptural form. In this work the artist *is* the work of art, a Picassoesque sculpture which makes fun of the concept of the artist as eye, peering through a chink in the veil at the light beyond. An implicit reference to Lüpertz's own bronze heads of the same year, such as *Die Bürger von Florenz*, is here neatly combined with several paradoxes - and perhaps even a reference to the artist's own self-confessed arrogance.

Ref: *Markus Lüpertz: Retrospective 1963-1990*, exh. cat., Centro Reina Sofia, Madrid, 1991, p. 134, no.78.

41

Marisol born 1930

Born in Paris to Venezuelan parents; lived in New York from 1950; studied at the New School, New York, 1951-4; included in *The Art of Assemblage*, Museum of Modern Art, New York, 1961; represented Venezuela at Venice Biennale, 1968. Retrospectives: Worcester Art Museum, Massachussetts, 1971; National Portrait Gallery, Washington, DC, 1991.

Portrait of Bishop Desmond Tutu, 1988 [illustrated p. 25]
Wood, stain and fluorescent light, 190.5 x 202 x 129.5 (75 x 79 ½ x 51)
Courtesy Sidney Janis Gallery, NY © Escobar Marisol/DACS, London/VAGA, New York 1993

Marisol was taught by Hans Hofmann, an influential figure in the development of American abstract expressionism. Her *assemblage* medium is close to that of fellow-Americans Robert Rauschenberg and Robert Indiana, though the deft interplay of wit and seriousness with a nod towards folk art identifies her own style. The dignified portrait of Desmond Tutu, like those of many other figures she admires, such as Picasso, Louise Nevelson and Georgia O'Keeffe has a wry edge linking it with a series of self-portraits from the early 1960s and with the gently mocking portraits of household gods of the day from the Royal Family to John Wayne. Much of the sitter is there by implication only, his physical presence pared down to head, hand, cassock, cross and crook; but it is precisely in the differing treatment of these parts that the cohesive force of the portrait lies. The stern features of the hewn head and the strong grasp of the hand, the 'real' crook with its reference to African craftsmanship and statesmanship, the box body symbolic in its size and colour, and the illuminated cross combine powerfully to convey the humanity and strength of the man, the stamp of his office and the spirituality of his calling. (HC)

Ref: Nancy Grove, *Magical Mixtures: Marisol Portrait Sculpture*, Smithsonian Institution, Washington, DC, 1991, p. 80, ill. p. 81.

42

Alice Neel 1900-1984

Born in Merion Square, Pennsylvania; studied at Philadelphia School of Design for Women (now Moore College of Art) 1921-5; moved to New York 1932; from 1938 exhibited at the ACA Gallery, New York. Solo exhibition: Artists' Union, Moscow, 1981. Retrospectives: Whitney Museum of American Art, 1974; Pennsylvania Academy of the Fine Arts, 1985.

Self-portrait, 1980 [illustrated p. 82]
Oil on canvas, 139 x 100.6 (54 ¾ x 39 ½)
National Portrait Gallery, Smithsonian Institution, Washington, DC

One of the foremost figurative and portrait painters of her generation in America, Alice Neel is virtually unknown in Britain. To those familiar with the rebelliousness of her whole approach to life, though, the astonishing frankness of her self-portrait at the age of eighty should come as no surprise . 'I don't look like I am!' she told Frederick Ted Castle in 1983. 'My spirit looked nothing like my body'*. Not that she had any need to spell it out in words when the painting makes the point with such eloquence: a cool dispassionate look, eyebrow slightly raised in quizzical self-appraisal reveals an active mind saddled with a sagging lumpy body. 'Death and I live here together,' she said, and it is probably not fanciful, given its use elsewhere in her work, to see an omen of death in the pyramidal blue shadow. The portrait was five years in the making, the flushed cheeks evidence of the tremendous effort involved in the act. But this is not an image to engage our pity. In the stoical dignity of the artist's gaze is a flinty triumph of the spirit over the body. (HC)

Ref: *Alice Neel, Paintings since 1970*, exh. cat., Pennsylvania Academy of the Fine Arts, Pennsylvania, 1985, ill. *From interview with Frederick Ted Castle in *Artforum Magazine*, October 1983.

43

Humphrey Ocean born 1951

Studied at Tunbridge Wells, Brighton and Canterbury Schools of Art, 1967-73; artist-in-residence with Paul McCartney's band *Wings* tour of USA, 1976; won National Portrait Gallery's *Portrait Award*, 1982; commissions since 1980 include works for Imperial War Museum and National Portrait Gallery. Solo exhibitions: Ferens Art Gallery, Hull, 1986; *Double Portrait*, Dulwich Picture Gallery, London (and tour), 1991-3.

Return from Big Mouth, 1990/3 [illustrated p. 85]
Oil on canvas, 198 x 183 (78 x 72)
The Artist

Despite the hazards of basing his career on the commissioned portrait, Humphrey Ocean has continued to develop and grow as an artist, his progress occasionally punctuated by large set-piece paintings. The narrative element which was always implicit in major early works like *Lord Volvo* (1982) here commemorates his first trip to Brazil, with anthropologist Stephen Nugent. As in Brazil, so in Ocean's painting - it was clearly the popular culture of the region, with a backward nod at Hockney, which inspired Ocean. The sober and reflective portrait of his companion shows a tray of more conventional Amazonian artefacts. The artist stands forward perhaps with a slight element of self-mockery, and accepts responsibility for offering his own view of the expedition. Alterations to the painting since it was first exhibited at the Royal Academy in 1990 have effectively suppressed the suggestion of spatial depth and have turned the remaining tiled floor into another element in the 'collage'.

Ref: *Humphrey Ocean*, exh. cat., Ferens Art Gallery, Hull, 1986; Stephen Nugent, *Big Mouth: The Amazon Speaks* (with drawings by Humphrey Ocean), London, 1990.

44

Bryan Organ born 1933

Born in Leicester; studied at Loughborough College of Art and Royal Academy Schools, 1952-9. First solo exhibition: Leicester City Art Gallery, 1958; has shown at the Redfern Gallery, London, since 1967; numerous public commissions have included portraits of the Prince and Princess of Wales for the National Portrait Gallery in 1980 and 1981.

President François Mitterand, 1984 [illustrated p. 21]
Acrylic on canvas, 127 x 127 (50 x 50)
Private Collection, Paris

The public patronage of the arts which has flourished in France during the presidency of François Mitterand is in no small measure a reflection of his own interests and private patronage (he has also commissioned Jean Hucleux, see cat. no. 32). It was on the occasion of the dinner at the National Portrait Gallery for the London Economic Summit in June 1984 that the President saw Bryan Organ's work and subsequently commissioned this portrait. Organ's own brand of realism is firmly rooted in a long British tradition of portraiture from Van Dyck to Reynolds, through to Lawrence and, more recently, Organ's teacher, Sutherland which subtly enhances the sense of occasion and position implicit in the commission while nevertheless retaining the integrity of the sitter. Combined with the impeccable contemporaneity of Organ's stylistic devices this has made him a formidable figure in the realm of VIP portraiture (a role he views with mixed feelings). The portrait of President Mitterand uses the familiar devices of strong verticals and horizontals, low viewpoint and one key piece of incidental information (here doors from the Elysée Palace) to create a subtly urbane image of a man of power and influence.

Ref: Norbert Lynton, *Picturing People*, exh. cat., British Council, London, 1989.

45

Nam June Paik born 1932

Born in Seoul, Korea; fled to Hong Kong, 1949 and then to Japan; studied music and art history, Tokyo University; music at Munich University and the Conservatory, Freiburg; first robots, 1963; first video installation, 1965. Major solo exhibitions: Hayward Gallery, London, 1988; Seoul, Korea, 1990; Basel, Zurich, 1991-2.

Beuys, 1990 [illustrated p. 18]
Video sculpture, 265 x 188 x 95 (104 ⅜ x 74 x 37 ⅜)
Courtesy Carl Solway Gallery, Cincinnati Ohio, USA

Nam June Paik was associated with Beuys in the early 1960s in the German-based *Fluxus* group and was in the forefront of the happening and performance art movement. Traces of their collaboration may perhaps be found in the grand piano which crops up in certain Beuys installations such as *Plight* (1963-85). Since 1963, Paik's inventive deployment of the video screen has ranged from *Zen for TV* with its single line on the screen of a television set lying on its side to huge multiples like the *V-Yramid* (1982), and he is generally considered to be the father of video art, with its legacy of the now universal 'pop' video. The recent video sculptures and video portraits have their formal origins in Paik's *Robot* figures of the sixties. *Charlotte Moorman* (1990) pays anthropomorphic homage to Paik's cellist collaborator in musical happenings. One of several tributes to Beuys, this 1990 version salutes the unmistakable personal appearance cultivated by Beuys, as do the portraits by Warhol (see no. 58)

Ref: *Nam June Paik: Video Works 1963-88*, exh. cat., Hayward Gallery, London, 1988; *Nam June Paik: Video Time-Video Space*, exh. cat., Stuttgart, 1991.

46

Eduardo Paolozzi born 1924

Born in Leith, Edinburgh; studied at Edinburgh and Slade School of Art, 1943-7; member of the Independent Group, 1952; delivered lecture on *Bunk* at the ICA, London, 1953; numerous public commissions in Britain and Germany; teaching appointments have included professorships at Munich and the Royal College of Art. Retrospectives: Tate Gallery, 1971; Royal Scottish Academy (tour to Munich, Cologne and Breda) 1984-5. Knighted 1989.

Head of Hephaestus, 1987 [illustrated p. 86]
Bronze, 61 x 39.4 x 39.4 (24 x 15 ½ x 15 ½)
Peter E. Davidson

The recurrent interest in portraiture throughout Paolozzi's art from the earliest collages to the sculpted heads of the eighties such as *The Critic* (1984), has been more in the nature of an exploration of its resonances and ambivalences than a search for likeness. When commissioned by Peter Davidson to produce a monumental self-portrait for the façade of a new office block in Holborn, London, Paolozzi was able to turn his attention to the more traditional problem of making a specific statement about one individual, in this case himself. Paolozzi conceived the whole-length figure of the artist as Hephaestus, the Greek Vulcan. The statue's two hands hold several hermetic objects, offered, as Duncan Macmillan has pointed out, almost ritualistically to the viewer. The head, from which this is a unique cast (slightly leaning forward in the original), took as its point of departure a rather neo-classic portrait bust of Paolozzi by Celia Scott. Dissected vertically and horizontally, though in a less drastic manner than the earlier portrait heads, the likeness was reassembled and refashioned, the rivet-like insertions suggesting perhaps both psychological complexities and creative energy from within.

Ref: *Paolozzi Portraits*, exh. cat., National Portrait Gallery, London, 1988, no. 21, ill p. 39; *Eduardo Paolozzi - Nullius in Verba*, exh. cat., Talbot Rice Gallery, University of Edinburgh, 1989, no. 12.

47

A. R. Penck born 1939

Born Ralf Winkler in Dresden; met Michael Werner who championed his work outside the GDR, 1965; collaborations with Immendorff following their meeting in Berlin, 1977; left GDR, 1980; appointed professor at Kunstakademie, Düsseldorf, 1987. Retrospectives: Bern, 1975; Cologne, 1981; Nationalgalerie, Berlin, 1988.

Self-portrait 8, 1989 [illustrated p. 91]
Acrylic on canvas, 130 x 100 (51 ¼ x 39 ⅜)
Courtesy Galerie Michael Werner, Cologne and New York

A. R. Penck's paintings with their language of hieroglyphs and symbols, are usually discussed in terms of his interest in communication and information theory and a (dubious) link with what is nebulously known as neo-expressionism. The significance of certain simple shapes, lines and symbols is certainly basic to Penck's investigation of forms of self-expression. In the large, sometimes mural-size paintings this can become so complex that the spectator is thrown back on his instincts for interpretation. In contrast, the less well known series of self-portraits seems to represent a far more straightforward search for solutions to a traditional problem. At first sight Penck's attempts at self-interpretation in this 1989 painting seem purely formal - straight lines for beard, an oval for the mouth, circular symbols for the eyes and so forth; but taken in conjunction with the other sometimes very different and even representational selves such as *Self-portrait (influenced by Immendorff)*, 1991, it becomes clear that they are all in some way both autobiographical and interpretative. The *Self-portrait 8* seems to pose the question: is this Penck more or less than the schemata his work presents to the world or is this image simply a mask?

Ref: *A. R. Penck*, exh. cat., Nationalgalerie Berlin and Kunsthaus Zurich, Munich, 1988; *A. R. Penck, Analyse einer Situation*, exh. cat., Staatliche Kunstsammlung Dresden, 1992.

48

Tom Phillips born 1937

Born in London; studied at St Catherine's College, Oxford and Camberwell School of Art (1961-3); included in *Young Contemporaries*, 1964; first publication of page from *A Humument*, 1967; illustrated and published his translation of Dante's *Inferno*, 1983; *A TV DANTE*, 1988-9. Solo exhibitions include: *Tom Phillips, The Portrait Works*, National Portrait Gallery, 1989-90; *Tom Phillips, Works and Texts*, Royal Academy, London, 1992.

Five Ex-Pythons, One Ex-Person & a Parrot (deceased), 1989-93 [illustrated p. 47]
Oil on panel in seven sections (with stuffed parrot), 119.4 x 96.5 (47 x 38)
The Artist

An artist obsessed with ideas and words, and their myriad permutations through the visual imagery of his painting, Tom Phillips is also passionate about the other people who originate those words and ideas and enjoys the 'sustained intimacy' of portrait sittings. The difficulty of re-assembling the group of actors, writers, directors and artists who together created *Monty Python's Flying Circus*, a major cultural and social landmark not only in British television but in the fabric of British life between 1969 and 1974, took Phillips back to the polyptych for what is in essence a memorial tribute. Each head is painted from a watercolour portrait from life, their identities (and that of the artist) concealed beneath typical Phillips anagrams. Terry Jones, Terry Gilliam and Michael Palin were completed first, and the portrait of Graham Chapman (bottom left with dusty halo) was painfully achieved during his final illness. Even the deceased parrot (a reference to the team's most celebrated and surreal sketch) lends, after the initial smile of recognition, an air of gloom to the proceedings.

Ref: *Tom Phillips, The Portrait Works*, exh. cat., National Portrait Gallery, London, 1989, p. 98; *Tom Phillips, Works and Texts*, exh. cat., Royal Academy of Arts, London, 1992.

49

Sarah Raphael born 1960

Born in Suffolk; studied at Camberwell School of Art, 1977-81; included in *Portrait Award*, National Portrait Gallery, 1982; two works purchased by the Metropolitan Museum of Art, New York, 1989; illustrated *The Hidden I* by her father, Frederic Raphael, 1990. Solo exhibitions: Christopher Hull Gallery, London, 1985; Agnew's, London, 1989, 1992.

Sir Garfield (Garry) Sobers, 1992 [illustrated p. 38]
Oil on canvas, 61 x 53 (24 x 20 ⅞)
Marylebone Cricket Club

After the larger-scale eclecticism of Sarah Raphael's early work of the 1980s, her landscapes and subject pictures seem to have settled into a closed world somewhere between early Stanley Spencer and Samuel Palmer, a world that is distinctly British in appearance but shot through with anxiety and shadows. From this the small portraits, which are a now regular part of her output, appear like windows, bright, intense, full of daylight and humanity. This portrait of the distinguished Barbados-born cricketer, commissioned by the MCC, is a remarkable example of what used to be called a 'speaking likeness'. Sobers' direct and assessing gaze transfixes the viewer and as soon as our attention wanders down to the huge and eloquent sportsman's hands we are drawn back to the vital force behind them. The usual melancholy and tension which characterizes Raphael's colours is subverted by the warmth and resonance of Sobers' West Indies blazer, and she has created a vivid and complex portrait of unusual depth.

Ref: *Sarah Raphael: Paintings & Drawings*, exh. cat., Agnew's, London, 1992.

50

Sara Rossberg born 1952

Born in Recklinghausen, Germany; studied at Frankfurt and Camberwell, 1971-8; prize winner *John Moores Liverpool 16*, 1989; included in *Portrait Award* at the National Portrait Gallery, 1989, 1990 (commended), 1993. Solo exhibitions include: Thumb Gallery, London, 1988, 1991; Rosenberg & Stiebel, New York, 1990, 1991; Jill George Gallery, London, 1991; City Museum and Art Gallery, Warrington, 1992. Retrospective: Newport, Cardiff, Durham, 1989.

Runner, 1989 [illustrated p. 63]
Acrylic on canvas, 152 x 214 (59 ⅞ x 84 ¼)
The Artist

Up until 1989 Sara Rossberg's work presented in photo-realist style single figures or groups in specific but common situations; in general terms it dealt with the crucial gap between recognition and knowledge. An increasing refinement of technique and exploitation of the range of technical possibilities available in modern paints led to a gradual break through the photo-realist barrier; *Runner*, with its different textured areas, is an initial exploration of this development. The enigmatic arrangement of the figures (modelled by friends) indicates a probable metaphor for isolation, and many of Rossberg's paintings have dealt with this theme in various guises. Increasingly, however, in her new and ever larger single heads and figures and in the almost relief-like application of paint, incidental information and local colour have been pared away to a near abstract figuration of person, paint and mood in her most recent work. Like some of the very different exponents of the 'new painting' in Rossberg's native Germany, the portrait though never the *subject* of her work, is an indivisible part of it.

Ref: *Sara Rossberg, Figuratively Speaking*, exh. cat., Rosenberg & Stiebel, New York, 1990.

51
Marty St James and Anne Wilson born 1954 and 1955
Both studied at Cardiff College of Art; have worked together since 1982 on performance, installations and video works. Installations/exhibitions include *Romance Don't Dance Alone*, Arnolfini, Bristol, 1986; *Civic Monument*, Birmingham, Glasgow, and Serpentine Gallery, London, 1990. Video works include *Hotel*, commission for Channel 4 Television/Arts Council, 1988-9; *Video Portraits*, National Portrait Gallery, London, 1990.

The Smoking Man, 1991-2 [illustrated p. 75]
Miniature video portrait, 33 x 31 (13 x 12 ¼)
The Artists

The relationship of performance to video art has seldom been clearer than in the work of St James and Wilson, and while continuing to explore the paradoxes inherent between the reality of human behaviour and the mechanical objectivity of video, they have been unique in applying the medium's possibilities to the individual in the form of portraits. These are usually very specifically designed to display one aspect of the subject's achievements or character (Duncan Goodhew *swims*, indeed spectacularly on eleven screens; actress Julie Walters 'rabbits on', as on stage so in life), St James and Wilson's portraits insist on what we already knew: that most portraits only tell us what the artist wants us to know. In *The Smoking Man*, Giuliano Pirani, the smoker is manipulated by the artists to concentrate on his little vice. The graphic and nostalgic associations of smoking are exploited to the 'n'th degree with no didactic message about the inherent pleasures or dangers of the habit but an almost historical sense of a thousand thirties film stills and atmosphere-setting shots.

Ref: *Video Portraits by Marty St James and Anne Wilson*, exh. cat., National Portrait Gallery, London, 1990.

52
David Salle born 1952
Born in Norman, Oklahoma; studied at Wichita Art Association and California Institute, Valencia, 1961-75; moved to New York, 1975. Solo exhibitions: throughout USA and Europe from 1975 including Rotterdam, 1983; University of Pennsylvania (and tour) 1986-8. Stage design includes American Ballet Theatre's *The Mollino*, Washington, DC, 1986.

In the Early 1980s (Portrait of A. E.), 1984 [illustrated p. 36]
Acrylic on canvas, lead and acrylic on wood, 213.4 x 274.3 (84 x 108)
Collection FAE Musée d'Art Contemporain, Pully/Lausanne

David Salle's work has always played on the unexpected and often on the inexplicable, and characteristically combines a series of eclectic images, sometimes taken from art history and layered together with virtually anything that might seem to be their antithesis. The notion of a contemporary portrait, in itself unexpected in Salle's *oeuvre*, is here paired with a Jasper Johnsian collage of cutlery which from any distance might appear to be either an abstract in monochrome or a metallic relief. The portrait (of successful Wall Street financier and collector Asher B. Edelman), like most of Salle's imagery derived from contemporary sources, is itself in monochrome. The diptych combination of image and apparent blank suggests here a possible reminiscence of early Warhols in this format. The small 'patch' on the settee confirms that the portrait is not in any sense a reality; the leaden collage of unusable domestic utensils offers a mute comment on this.

Ref: Robert Rosenblum, Rainer Crone & Dennis Cooper, *David Salle*, exh. cat., Zürich, 1986; information from Robert Pincus-Witten.

53

Tai-Shan Schierenberg born 1962

Born in England; grew up in Malaysia, North Wales and Germany; studied at St Martin's School of Art, 1981-5; co-winner of *Portrait Award*, National Portrait Gallery, London, 1989; first prize winner at Royal Overseas League exhibition, *A View of the New*, 1990. Solo exhibitions: Diorama Gallery, London, 1988, 1991; Flowers East, London, 1992.

John Mortimer, 1992 [illustrated p. 39]
Oil on canvas, 182.5 x 183 (71 ⅞ x 72)
National Portrait Gallery, London

There was little in what we knew of Schierenberg's work to prepare us for the extraordinary impact of his portrait of writer and dramatist John Mortimer, commissioned for the National Portrait Gallery. The virtuoso realism and the scale and grandeur of the concept all suggested a new Sargent, but equally raised the question: what next? Like one or two other painters of his generation (Celia Paul for instance) Schierenberg has his roots firmly in the expressionistic aspect of the School of London represented by Kossoff, Auerbach and Freud but presents a distillation of their experience without aping it. The potential dichotomy of direction in his work is plainly visible here: the large, enigmatic and painterly self-portrait in the background looms over the clarity and presence of the public figure, painted for a rather different purpose. The searching studies of self and friends and lyrical swirling landscapes in Schierenberg's subsequent show at Flowers East demonstrated quite clearly that consolidating his approach to painting is his first priority. Whether or not the Mortimer portrait raised the spectre of a creative cul-de-sac, the artist alone can demonstrate.

Ref: Edward Lucie-Smith, 'Tai Shan Schierenberg' in *Contemporary Art*, Autumn 1992, pp. 26-7.

54

Julian Schnabel born 1951

Born in New York, studied at Houston University and Whitney Museum, New York, 1969-74. First solo exhibition: Houston, 1976; began 'plate' paintings, 1979, sculpture, 1983. Exhibitions include Tate Gallery (and tour to Stedelijk, Amsterdam), 1982. Retrospective: Whitechapel Art Gallery, London (and tour to Paris, Düsseldorf, New York, San Francisco, Houston), 1986-8.

Untitled (Tim), 1989 [illustrated p. 66]
Oil and bondo with plates on wood, 182.9 x 152.4 (72 x 60)
The Pace Gallery, New York

As *enfant terrible* of the New York art world, Julian Schnabel filled something of the vacuum left by the death of Warhol in 1987. It is tempting to speculate also whether the passing of the court painter to New York society had anything to do with the appearance the same year of Schnabel's principal series of portraits. Their work has little in common, Schnabel's being highly subjective and essentially expressive. After the initial shock of the 'plate' paintings had subsided, Schnabel's portraits were (pointlessly) criticised for their virtuosity and glamour. Though not precisely weighed down by existentialist *angst* (why should this be a pre-requisite for contemporary portraiture?), they are extremely shrewd and often breathtakingly beautiful. The broken plates are of course an integral part of Schnabel's method and not merely a sensation-seeking challenge to be overcome. Once that is grasped, one can only be moved at the way the contours of the broken crockery are manipulated to create light and movement in the musculature, the squareness of a cheek bone, the delicate curve of a wave in the hair and a pinch of tension round the mouth. The brilliance of the expressionist colour comes almost as a bonus.

Ref: *Julian Schnabel: Paintings 1975-86*, exh. cat., Whitechapel Art Gallery, London, 1986; *Julian Schnabel, C. V. J., Nicknames of Maitre D's & other excerpts from life*, New York, 1987.

55

George Segal born 1924

Born in New York; studied at Cooper Union, Pratt Institute and Rutgers University. First solo exhibition (paintings): Hansa Gallery, New York, 1956; associated with Pop movement; first outdoor happenings at his New Jersey home, 1958; abandoned painting for sculpture, around late 1950s. Commissions include *The Holocaust*, Lincoln Park, San Francisco, 1983. Retrospectives include: Minneapolis, 1978-9; Caracas, 1991.

Helen against Door, 1988 [illustrated p. 67]
Plaster, wood and acrylic paint, 121.9 x 66 x 38 (48 x 26 x 15)
Collection of Agnes Gund

George Segal's association with Pop Art was always oblique, one of similarity of method and approach rather than of purpose, and his groups of ashen plaster figures in urban spaces have a bleak, directionless air which anchors them firmly in the context of the art of the immediate post-war period. His figures are cast from life, a process which not only heightens the sense that it is the individual who is adrift in urban society, but also, with the inevitable closed eyes gives Segal's figures the haunted look of sleepwalkers. Recent work suggests a more personal approach (Segal is approaching his seventieth birthday), and the series of single figures against domestic backgrounds, mostly with simplified use of local colour, are, even if anonymous, portraits in every sense of the word. The use of the half-length figure confirms the traditional portrait format, and the architectural framework offered by a door or a window suggests an imaginative reworking of the sculptural relief. The image of the artist's wife, Helen, in this and other works is, despite its sombre melancholy and mechanical origins, one of grave beauty and tenderness.

Ref: Sam Hunter, *George Segal*, exh. cat., Barcelona, 1989; *George Segal, Works 1958-1989*, exh. cat., Contemporary Art Museum of Caracas, Venezuela, 1991.

56

Amikam Toren born 1945

Born in Jerusalem; lives and works in London; since first solo exhibition, Maserik Gallery, Tel Aviv, 1967, has exhibited in Britain, Poland, The Netherlands, France, Germany and Japan; included in the Paris (1967) and Venice (1984) Biennales; prize winner at *John Moores Liverpool 16*, 1989. Solo exhibition: Ikon Gallery, Birmingham, Arnolfini Gallery, Bristol, 1990-1.

Self-portrait, 1982 [illustrated p. 74]
Pulverised glass and PVA over drawing, 39.4 x 31.8 (15 ½ x 12 ½)
Private Collection, London. Courtesy Anthony Reynolds Gallery

Toren was included in Sarah Kent's 1984 exhibition at the Serpentine Gallery, *Problems of Picturing,* and that is indeed what much of his work is about. Toren has also taken 'found' portraits which he then semi-obliterates with fragments of printed commentary, as much a critique of what this author is at present trying to do as of the weight of associations, both relevant and irrelevant, which every image contains. A recent series of self-portraits took the form of diptychs, each with an exaggeratedly grotesque self-image on one panel created from the pulverized remains of the enigmatic title cut out of the other. The present work makes nonsense of the piece of glass invariably placed between the viewer and (portrait) drawings in museums and galleries. Pulverised into its constituent dust, the glass becomes part of the drawing. Without in any way destroying the underlying critique, the work like every good concept assumes a life, validity and surreal beauty of its own.

Ref: *Amikam Toren*, exh. cat., Ikon Gallery, Birmingham, 1990.

57
John Ward born 1917
Born in Hereford; studied at Hereford School of Arts & Crafts and the Royal College of Art, 1932-9; fashion illustrator for *Vogue*, 1948-52; mural in Challock Church, Kent, 1956; numerous public and private portrait commissions; illustrated books by Laurie Lee, H. E. Bates, Richard Church and Joyce Grenfell. Retrospectives: Royal Museum, Canterbury, 1987; Agnew's, London, 1990.

Norman Parkinson, 1988 [illustrated p. 31]
Oil on canvas, 244 x 122 (96 x 48)
John Ward

It was the photographer Norman Parkinson who initiated John Ward into the pressures and tricks of the trade of the world of fashion while working together on *Vogue* in 1948. They remained close friends and the portrait was painted at Parkinson's invitation for his seventy-fifth birthday under not altogether ideal conditions at his home in Tobago. This essay in the grand manner demonstrates how a thorough grasp of the art of the past can still revivify an image of the present and is a magnificent example of the unique blend of journalistic brilliance and sense of historical tradition which has made Ward Britain's most respected society portraitist. The artist has stated that he began the portrait with the example of Delacroix's 1826 portrait of Baron Schwiter (National Gallery, London), but it is the easy nonchalance of Sargent's *Sir Frank Swettenham* (National Portrait Gallery, London) which comes first to mind. Despite the bravura of the brushwork and cosmopolitan air, it is, like most of Ward's work, an extremely accurate likeness which does not attempt to conceal the truculent determination of his sitter.

Ref: John Ward, *The Paintings of John Ward*, London, 1991, pp. 88-9, ill.

58
Andy Warhol 1928-1987
Born in Pittsburgh; studied at Carnegie Institute, Pittsburgh, 1945-9; worked as commercial artist in New York, 1949. First solo exhibition: Hugo Gallery, New York, 1952; pioneer of American Pop movement, exhibited worldwide; made films from his studio, *The Factory*, 1963. Retrospectives: Kunsthaus, Zurich, 1978; New York and Paris, 1989-90.

Joseph Beuys, 1980 [illustrated p. 19]
Acrylic and diamond dust on canvas, screenprint, 213.4 x 177.8 (84 x 70)
Laura and Barry Townsley

The constant reappearance of the image of Joseph Beuys in the works of artists as diverse as Warhol, Nam June Paik (see cat. no. 46) and Immendorff (see cat. no. 34) is a mark of the almost universal respect in the international community of artists for a great revolutionary of post-war art. Warhol used the portrait of Beuys repeatedly in the last ten years of his life and among all the more frivolous society portraits of this period it retains the innate dignity and respect inherent in the image. If the message of the portraits is that Beuys too has become a superstar, the liberal use of kitsch diamond dust suggests the possible derivation of art from even the humblest of materials - a sentiment not a million miles removed from Beuys's own.

Ref: David Bourdon, *Warhol*, New York, 1989, p.385; *Andy Warhol: A Retrospective*, exh. cat., Museum of Modern Art, New York, 1989.

59
Alison Watt born 1965
Studied at Glasgow School of Art, 1983-8; winner, *Portrait Award*, National Portrait Gallery, London, 1987 and commissioned to paint HM Queen Elizabeth, The Queen Mother, 1989. Solo exhibitions: The Scottish Gallery, London, and Glasgow Museums and Art Galleries, Kelvingrove, 1990; Flowers East, London, 1993.

Cupid after his Bath, 1991 [illustrated p. 57]
Oil on canvas, 152.4 x 91.5 (60 x 36)
Courtesy Angela Flowers Gallery

Much of Alison Watt's painting reads like a textbook for post-modernism and even the strong sense of gender which burst to the surface of the large allegories and triptychs in her last exhibition at Flowers East is tempered with ironical cross-references between old masters and modern life. In *The Lovers* (1991), two stylized self-portraits like Piero della Francesca saints, the one androgynous in boxer shorts the other, rounded, modest in creased tights, unite as the twin polarities of creation. There is little of the long-suffering Psyche in Watt's make-up and here her handsome but lumpy *Cupid* (an ex-boyfriend) is the subject of acute observation, unaware of her all-too-seeing eye. Tiny amoretti begin to encircle him and suggestively proclaim her dominion over him. The allusion to Ingres, the archetypal painter, idealizer and lover of women (and a constant point of reference throughout Watt's work) underlines a double irony not only in the role reversal but also in the shrewd realism of Watt's approach to her portrait.

Ref: *Alison Watt, Paintings*, exh. cat., Flowers East, London, 1993 (exhibited, not. ill.)

60
Glynn Williams born 1939
Born in Shrewsbury; studied at Wolverhampton College of Art and British School, Rome, 1955-63; included in *Young and Fantastic*, ICA, London, 1969; taught at Wimbledon School of Art, 1976-90; Professor of Sculpture, Royal College of Art since 1991. Solo exhibition: Bernard Jacobson Gallery, London, 1992. Retrospective: Margam Park, Port Talbot, 1992.

Self-portrait, 1985 [illustrated p. 92]
Weatherbed Ancaster stone, 48.9 x 41.9 x 31.7 (19 ¼ x 16 ½ x 12 ½)
Claptrap

The knowledge of the extent to which the shape and natural strengths and weaknesses of the carver's material may have influenced the finished sculpture is seldom vouchsafed to the spectator, but there is a strong sense of organic and natural form running through all Glynn Williams's work as much (if not more so) in the early abstract and conceptual pieces as in the mature stone carvings and bronzes. The pink velvet shoots and cotyledons of *Raspberry Queen* (1960) push up from the ground like some monstrous tropical seedling; *Woman in chair* (1991) is stratified and fissured like a natural outcrop of limestone, sharp and architectural where protected, softened and shaped where exposed to the weather. In this self-portrait the sculptor identifies himself totally with his materials. The head thrusts up irresistibly from the stone, the unhewn shoulder representing simultaneously both anatomy and the raw material. The sideways tilt of the head indicates a sense of struggle; the act of creation is not achieved without effort.

Ref: Sean Kelly & Edward Lucie-Smith, *The Self Portrait, A Modern View*, London, 1987, p. 44-5; Glyn Hughes, *Glynn Williams*, exh. cat., Bernard Jacobson Gallery, 1992.

61

Anthony Wilson born 1959

Born in Blackpool; studied at Brighton Polytechnic and Goldsmiths' College, London, 1979-85; slide/tape based installations include *Satellite*, Riverside Studios, London, 1987; *Achievers-Strivers-Strugglers-Survivors*, Venice Biennale, 1990; solo exhibition Anthony Reynolds Gallery, London, 1989; included in *Signs of the Times*, Museum of Modern Art, Oxford, 1990.

WHATS THAT LOOK SUPPOSED TO MEAN, 1992 [illustrated p. 79]
Etched mirror glass on medium-density fibreboard, 30.5 x 30.5 (12 x 12)
Courtesy Anthony Reynolds Gallery

The centuries-old paradox of the mirror-image and our reaction to it is here played for simple but meaningful effect - a reminder that the best forms of conceptualism require the viewer's active participation and, less commonly, can be amusing. Wilson's mirror demands at least three looks/reactions: the initial recognition (possibly even the shock and embarrassment) that we are looking in a mirror in a public situation; the look of enquiry as we attempt to read the elegantly engraved message; and latterly, the look of amusement/indignation when we interpret the message. Any other looks are an added bonus. As simple as the motto in a Christmas cracker or a corny practical joke, Wilson's mirror invites more profound speculation on the nature and meaning of body-language and self-communication.

Ref: John Hilliard, *Anthony Wilson: Satellite*, exh. cat., Riverside Studios, London, 1987.

62

John Wonnacott born 1940

Born in London; studied at the Slade School of Art, 1958-63; included in *The Hard-Won Image*, Tate Gallery, London, 1984; *The Pursuit of the Real*, Manchester, London and Glasgow, 1990. Commissions for Scottish National Portrait Gallery, 1985-6, and Imperial War Museum, 1990-1. Solo exhibitions: The Minories, Colchester, 1977; Scottish National Portrait Gallery, 1986; Agnew's, London, 1992.

Ian with Renown IV, 1990-2 [illustrated p.56]
Oil on board, 162.2 x 82.5 (64 x 32 ½)
Thos. Agnew & Sons Ltd

One of the most respected realists in contemporary British art, the paintings of John Wonnacott evoke a range of reactions from wild adulation to indifference. Lacking the *frisson* of Freud's nudes and disorderly studio, their restricted subject-matter and life-school approach perhaps spring few surprises. The portrait of Sir Adam Thompson, commissioned by the Scottish National Portrait Gallery, however, was an amazing feat of compositional organisation and selective description which sent the viewer scurrying back to investigate further the run of quietist portraits from the artist's Leigh-on-Sea studio. Here time stands still as the artist explores the interplay of verticals, horizontals and diagonals, light and shade in a new corner of a familiar setting. Time weighs on the sitter's hands too, as a bankrupt fisherman friend contemplates the former source of his livelihood and the battleship at anchor. The obliqueness of the portrait is subtly echoed by the oblique view onto the outside world. This is an image of time and silence shared, only the red shirt indicating the stimulus of another presence.

Ref: *Recent Paintings: John Wonnacott*, exh. cat., Agnew's, London, 1992, no. 7, ill. p. 34.

63
Tom Wood born 1955
Born in Dar es Salaam; moved to Yorkshire, 1959; studied at Batley, Leeds and Sheffield Schools of Art, 1975-8; Artist in Industry placement with Vickers plc., 1983; prize-winner *Portrait Award*, National Portrait Gallery, London, 1985. Solo exhibitions include: Bradford, 1984, 1986; Dean Clough, Halifax 1987, 1989; Agnew's, London, 1990; Wakefield, 1990; King of Hearts, Norwich, 1992. Numerous commissions include Castle Museum, Norwich, National Portrait Gallery, London and Yale University, New Haven.

Old Science II, 1993 [illustrated p. 90]
Oil on panel and perspex, 38.2 x 50.8 (15 x 20)
Hart Gallery, Nottingham

Working away in Yorkshire and outside the London art world, Tom Wood has already produced a string of major portrait works which will ensure his lasting reputation. Thoughtful yet highly decorative, often full of still-life motifs and collage-like emblems, portraits such as the recent *HRH The Prince of Wales* (1989, on loan to the National Portrait Gallery, London) and *Sir Ernest Hall* (1989) demonstrate Wood's unique combination of gritty northern realism and visual inventiveness. Running parallel to the portraits are paintings and often large prints on thematic motifs which frequently mirror Wood's African heritage, and a long series of self-portraits is perhaps more closely related to these. Early works such as *The First Big Painting* (1976-7), *Adam* (1977-9) and *Naked Self-Portrait* (1978) indicate an exploration of his physical nature as much as of his status. Recent series such as *Soldier/Grill* and *Old Science* are analytical self-portraits, the geometrical motifs suggesting pressures and stresses, the grill alienation. They mark new stylistic approaches and are as much images of inquiry into Wood's art as into his own mind.

Ref: D. Hill & S. Morris, *Tom Wood* (Yorkshire Artists' II), Otley, Yorkshire, 1990.

64
Dmitri Zhilinski born 1927
Born in Sochi, on the Black Sea, Russia; studied, and subsequently taught at the State Surikhov Art Institute, Moscow; Professor and member of the Academy of Fine Arts. Solo exhibitions: Neue Galerie, Sammlung Ludwig, Aachen, and Embassy of the Soviet Union, Bonn, 1980; Sochi, Kiev and Lvov, 1982; Moscow, 1984; Paris, 1987.

Double Portrait of the Collectors Irene and Peter Ludwig, 1981 [illustrated pp. 40-41]
Egg tempera on boards (painted both sides), 118 x 118 (46 ½ x 46 ½)
Ludwig Museum, Budapest

A respected academician, Zhilinski was one of the established Soviet artists who benefited from the increased liberalism of the Gorbachev years (in 1987 he exhibited his altar-piece-like *The Year 1937* which dealt with the Stalinist arrest of his father). The narrative and decorative elements in Zhilinski's work recall a folk art tradition with a glance across the quattrocentro at certain late nineteenth century symbolists; but in the context of the contemporary art in the various museums endowed by Irene and Peter Ludwig, the paintings acquire a post-modern air. The Ludwigs' patronage of a wide number of artists from former Eastern bloc countries is an indication of the catholic nature of their collecting habits which Zhilinski mirrors in a symbolic, fairy-tale like manner on the reverse of his portrait diptych. Interior/exterior, museum/sacred grove, masterpieces from the Ludwig collection hover between reflection and reality with the intangibility of treasures under glass. The principal portrait shows the Ludwigs at home as collectors of modern art. Naive perhaps in its interpretation of contemporary Western European style, its simple dignity and objectivity cannot entirely conceal deeper complexities of characterization.

Ref: *Zhilinski Paintings and Graphic Works*, exh. cat., Moscow, 1984; *Zeitgenössische Kunst*, Ludwig Museum, Budapest, 1991, p. 119, ill.

Index of Lenders

(Names are followed by catalogue numbers.)

Hartmut and Silvia Ackermeier, Berlin no. 7
Thos. Agnew & Sons Ltd no. 62
Clive Barker no. 5
Tony Bevan no. 9
Trustees of the British Museum no. 34
Claptrap no. 60
Michael Clark no. 11
Peter Cropper no. 25
Peter E. Davidson no. 46
Anthony d'Offay Gallery, London nos. 12, 28, 38, 39
Drabinsky Gallery, Toronto no. 14
Angela Flowers Gallery no. 59
Elisabeth Frink no. 22
Agnes Gund no. 55
Richard Hamilton no. 28
Hart Gallery no. 63
David Hockney no. 30
Jean Hucleux no. 32
Sidney Janis Gallery, New York no. 41
Panayiotis Kalorkoti no. 35
Ludwig Museum, Budapest no. 64
Ludwig - Collection, Oberhausen, Germany no. 23
Loic Malle Fine Arts, Paris no. 32
Marlborough Fine Art (London) Ltd nos. 16, 37
Marylebone Cricket Club no. 49
Dr. Heinz Mättig, Wiederitzsch no. 29
Robert Miller Gallery, New York no. 36
Tim Miller no. 26
National Portrait Gallery, London no. 53
National Portrait Gallery, Smithsonian Institution, Washington DC no. 42
Humphrey Ocean no. 43
Pace Gallery, New York nos. 13, 54
Tom Phillips no. 48
FAE Musée d'art contemporain, Pully/Lausanne no. 52
Raab Boukamel Galleries Ltd no. 19
Anthony Reynolds Gallery, London nos. 24, 56, 61
Sara Rossberg no. 50
Marty St James and Anne Wilson no. 51
Mr René Schneider no. 6
Scottish National Portrait Gallery nos. 2, 8
Carl Solway Gallery, Cincinnati, Ohio no. 45
Tate Gallery no. 10
Laura and Barry Townsley no. 58
John Ward no. 57
Galerie Michael Werner, Cologne and New York nos. 40, 47
Sue and David Workman no. 31
Private Collections nos. 1, 3, 4, 15, 17, 18, 20, 21, 27, 33, 44, 56

Index of Artists

(Names are followed by page numbers. Numbers in roman refer to catalogue entries of works exhibited. Numbers in italics refer to illustrations.)

Andrews, Michael, 94, *35*
Arikha, Avigdor, 94, *16*
Auerbach, Frank, 95, *65*
Bacon, Francis, 95, *37*
Barker, Clive, 96, *62*
Barton, Glenys, 96, *24*
Baselitz, Georg, 97, *71*
Bellany, John, 97, *20*
Bevan, Tony, 98, *73*
Blake, Peter, 98, *53*
Clark, Michael, 99, *26-27*
Clemente, Francesco, 99, *45*
Close, Chuck, 100, *48*
Colville, Alex, 100, *58*
Conroy, Stephen, 101, *30*
Davies, John, 101, *60*
Dine, Jim, 102, *61*
Edwards, Peter, 102, *52*
Fetting, Rainer, 103, *83*
Finer, Stephen, 103, *23*
Freud, Lucian, 104, *51*
Frink, Elisabeth, 104, *87*
Gille, Sighard, 105, *22*
Golub, Leon, 105, *72*
Gordon, György, 106, *50*
Green, Anthony, 106, *32*
Hambling, Maggi, 107, *34*
Hamilton, Richard, 107, *59*
Heisig, Bernhard, 108, *64*
Hockney, David, 108, *33*
Hodgkin, Howard, 109, *70*
Hucleux, Jean, 109, *84*
Immendorff, Jörg, 110, *76-77*
Jones, Allen, 110, *17*
Kalorkoti, Panayiotis, 111, *78*
Katz, Alex, 111, *46*
Kitaj, R.B., 112, *44*
Koons, Jeff, 112, *88*
Kossoff, Leon, 113, *49*
Lüpertz, Markus, 113, *89*
Marisol, 114, *25*
Neel, Alice, 114, *82*
Ocean, Humphrey, 115, *85*
Organ, Bryan, 115, *21*
Paik, Nam June, 116, *18*
Paolozzi, Eduardo, 116, *86*
Penck, A. R., 117, *91*
Phillips, Tom, 117, *47*
Raphael, Sarah, 118, *38*
Rossberg, Sara, 118, *63*
St James, Marty & Wilson, Anne, 119, *75*
Salle, David, 119, *36*
Schierenberg, Tai-Shan, 120, *39*
Schnabel, Julian, 120, *66*
Segal, George, 121, *67*

Toren, Amikam, 121, *74*
Ward, John, 122, *31*
Warhol, Andy, 122, *19*
Watt, Alison, 123, *57*
Williams, Glynn, 123, *92*
Wilson, Anthony, 124, *79*
Wonnacott, John, 124, *56*
Wood, Tom, 125, *90*
Zhilinski, Dmitri, 125, *40-41*